IMAGES
of America

CAMBRIDGE

D1279568

IMAGES
of America

CAMBRIDGE

Gloria Johnson-Mansfield and A.M. Foley

ARCADIA

Copyright © 2002 by Gloria Johnson-Mansfield and A.M. Foley
ISBN 0-7385-1444-6

First published 2002.
Reprinted 2002.

Published by Arcadia Publishing,
an imprint of Tempus Publishing, Inc.
2 Cumberland Street
Charleston, SC 29401

Printed in Great Britain.

For all general information contact Arcadia Publishing at:
Telephone 843-853-2070
Fax 843-853-0044
E-Mail sales@arcadiapublishing.com

For customer service and orders:
Toll-Free 1-888-313-2665

Visit us on the internet at http://www.arcadiapublishing.com

Every effort has been made to respect and trace copyrights and check facts prior to publication. However, in some instances, this proved impossible. If notified of any omissions or errors, we will be pleased to correct future editions.

CONTENTS

ACKNOWLEDGMENTS

The authors are indebted to many people for their encouragement, support, and participation in making this book possible. Among those who shared their knowledge and valuable collections were Dorchester County Historical Society, especially the Research Collection Curator, Jean Jenkins; the staff of the Dorchester County Public Library; Russell and Ida Jane Baker Jr.; Anna L. Blocker; Commissioner Lawrence J. Bohlen; W. Lance Bramble; Earl and Shirley Brannock; William Brooks; Fr. Bruce Byrolli; Cambridge Police Department; Barry Collins; Dorchester Skipjack Committee; Captains Dwayne and Marion Durham and the Salvation Army; the late Capt. C. Calvert Evans; Chief Sewell Winterhawk Fitzhugh; Mary Lee Foxwell; Claude Gootee; Jan Gray; Rev. Enez S. Grubb; Rev. Leon B. Hall Sr.; Betty and C. Lee Harrison; Dr. Nan DeVincent-Hayes; John E. Jacob; Herschel Johnson; Charles and Karen Kelly; Jane Langrall; Dave Linthicum; James and Shirley McCready; Debra S. Moxey; Rev. Nathaniel W. Pierce; Richardson Maritime Museum; Virginia Skinner; J. Lynn and Theda Stubbs; Gary Thompson and the resident wizards of Hurst Creek Computers; Capt. Charles W. and Gloria Todd; Richard Travers; Harriet Tubman Organization; Commissioner Edward E. Watkins; Roger Guy Webster; Joan Whetmore; and Sylvia B. Windsor.

Especially helpful research resources were:

The Cambridge Record Historical and Industrial Issue, Albert E. Walker, Ed. and Comp. Cambridge, Maryland, 1908. The Daily Banner. Harper's Monthly.

Earle, Swepson, Ed. *Maryland's Colonial Eastern Shore*. Baltimore, Maryland: Munder Thomsen Press, 1916.

Footner, Geoffrey M. *The Last Generation: A History of a Chesapeake Shipbuilding Family*. Solomons, Maryland: Calvert Marine Museum Press, 1991.

Forman, H. Chandlee. *Old Buildings, Gardens and Furniture in Tidewater Maryland*. Cambridge, Maryland: Tidewater Publishers, 1967.

Historic Homes Survey by Michael Bourne, February 1976.

Johnson, Dr. James C., Ed. *Dorchester County: A Pictorial History*. Cambridge, Maryland: Dorchester County Bicentennial Commission, 1976.

McElvey, Kay Najiyyah, Ph.D. *Early Black Dorchester*. Ann Arbor, Michigan: U.M.I., 1990

Mowbray, Calvin W. *The Early Settlers of Dorchester County and Their Lands*. Cambridge, Maryland, 1981.

Mowbray, Calvin W. *First Dorchester Families, Vol. I*. Cambridge, Maryland, 1984.

Parishioners of St. Mary Refuge of Sinners. *The Catholic Church in Dorset, 1650–1972*. Cambridge, Maryland, 1972.

Price, Gertrude. *Zion Church Before 1900*. Cambridge, Maryland: Zion UM Church, 1980.

Reed, Paula S., Ph.D. *Cambridge Historic District, Wards I and III*. Cambridge, Maryland: Historic Cambridge, Inc., 1990.

Reid, Donald L., Webster, Roger Guy and Wright, Hubert H. IV. *Cambridge Past and Present*. Norfolk, Virginia: The Donning Company, 1986.

Vestry of Great Choptank Parish. Great Choptank Parish. Cambridge, Maryland, 1975.

Last but not least, for their encouragement and support, a sincere thanks go to family and friends such as Michael Foley and Ann Slattery. Rick Mansfield earns special mention for his many leads and support in the making of this book. Thank you Rick II and Katie, for being you.

INTRODUCTION

Not long after completion of the Dorchester & Delaware Railroad in 1869, *Harper's Monthly* reported a visitor's impressions upon awakening in Cambridge aboard an overnight train:

> My first view was of a sheet of sparkling blue water, the Choptank . . .The town, across a bridged inlet, shone in the sunshine, and the rich foliage in which its houses were buried rocked in a breeze so pure and fresh that it seemed to recreate the world. This cheerful impression remained with us; it would be difficult to find a more delightful little place than Cambridge. As old as its Massachusetts namesake, it has not even yet reached the conventional 2,000 inhabitants, but it has more good, and fewer mouldy, dilapidated houses than any ancient town we saw. I noticed four hotels, every one of which looked comfortable. Some of the houses must be more than two hundred years old, for they were built with bricks brought from England, and theirs is an honored and respectable, not a neglected, age.

The traveler's impression was correct. Cambridge was the heart of Eastern Shore influence in Lord Baltimore's Maryland, and for over a century thereafter, sending her sons to vital military, diplomatic, and governmental posts. The city today retains many reminders of its role in shaping the fledgling country and state, as well as reminders of the preceding Native American society.

Early settlers learned survival skills by emulating the native people they named Indians. Log canoes racing today on the Choptank River are remnants or replicas of a fleet of workboats, hewn from logs by descendants of European settlers, who learned this technique from Indians.

Cambridge was established by act of the Provincial Maryland Assembly in 1684 on land previously reserved for "the Indians, the ancient Inhabitants of this Province" that they "should have a convenient dwelling place in this their Native Country free from the encroachment and oppression of the English." In successive trades for reservation land, John Kirk(e) eventually acquired much of what is now Cambridge for 42 matchcoats. Since "private property" was an alien concept to the Indians, and they specifically retained the right to hunt any part of the reservation uncultivated, they may well have wondered why Mr. Kirk gave them all those coats. As deeds continued to change hands and conflicts inevitably arose, the Indians withdrew to the northern part of their reservation. After Cambridge was designated the county seat of what was then called Dorset, a courthouse was established and Christ Church was built, along with a jail, pillory, and whipping post. Affairs of Church and State were administered by the Proprietary government and Assembly in Annapolis, the county court appointees and Sheriff, and vestrymen of Great Choptank Parish.

Of the Europeans settlers, Col. James Wallace observed in a July 4, 1884 speech that Cambridge's "population was very select and society highly polished. Here were located the Judges of the Court, the clerks, the lawyers, the physicians, the teachers—the cultivated people of the land . . . They came here to rest, and they found it; they lived the life of gentlemen of the olden time. They were gallant, chivalric, polite, cultivated and hospitable. They had no mails, no newspapers, no politics, no heated discussions; they devoted themselves to literature and leisure."

The colonel, of course, omitted those who arrived with little or no means, or as slaves or indentured servants. But day-to-day life generally was orderly for all and changed little before

the Revolution, and for some time thereafter. By Act of Assembly in 1745, progressive citizens had succeeded in enacting a sanitary measure banning swine and geese in town, but 140 years later, throughout the 1880s, the *Democrat and News* waged a campaign against cows free-ranging around High Street. In those years following the Civil War, Cambridge had begun to boom. Nature's least mobile creatures—oysters stuck for life to beds of shell accumulated over millennia on the Choptank River bottom—had suddenly turned to gold. Around that time, somewhat coincidentally, pressure canning technology developed for large-scale preservation of oysters; railroad lines networked from Cambridge to California; and steamboats reached upriver to Cambridge through a newly-dredged shipping channel. Thus oysters no longer had to be consumed near salty waters, but could be shipped inland to satisfy appetites to the west. In addition to succulent flavor, the oyster's fabled stimulative reputation undoubtedly encouraged sales.

Oyster packing houses sprang up along Cambridge Creek. A boom in construction ensued as entrepreneurs and laborers gravitated to town from out-lying parts. Lumber mills and shipbuilders proliferated and prospered. Local dredgers and tongers competed for the harvest, and boats from other counties and states followed. To eliminate outsiders, the General Assembly enacted restrictions, which the sheriff struggled to enforce. Competition became so heated the legislature created the Maryland Oyster Navy to keep peace and enforce restrictions. Shots were fired and battles erupted before law and order returned. As the oyster beds inevitably declined, canners diversified into fruits and vegetables.

All this harvesting and processing was labor-intensive. Overworked locals were supplemented seasonally by crews from Baltimore. Men loosely termed "Paddies" or "tramps" crewed aboard oysterboats. Groups of families lived in communal houses provided by canneries. The First and Second World Wars brought huge orders for canned rations. Increasing competition from California canneries wasn't felt until peace returned.

Leaner times in the generally turbulent 1960s saw Cambridge again divided, this time along racial lines. Where former divisions pitted Revolutionary Patriot against Tory, Blue against Gray, or tonger against dredger, the Civil Rights Movement of the 1960s highlighted inequities in a supposedly "separate but equal" social order that was as natural as breathing to many. Fortunately, accommodations were affected without the deadly results that accompanied some earlier clashes, most notably on Culp's Hill at Gettysburg.

From a Cambridge point of view today, at the dawn of a new century, with a new bridge, a new visitors center, and a new resort visible on the horizon, it may be time to briefly revisit the more distant past.

One
PROVINCIAL CAMBRIDGE

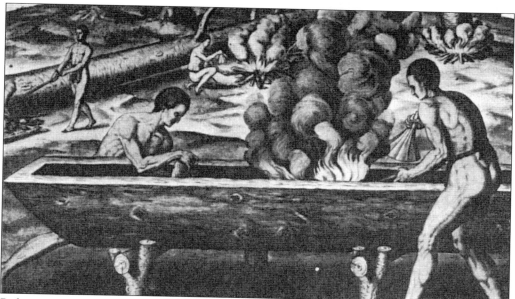

Before contact with Europeans, Native Americans fashioned dugout canoes from single logs. A suitable tree was selected from the vast forest, girdled and felled over time, then hollowed out by alternately burning and scraping the inside with shells. Settlers adopted this basic scheme, but accelerated the process with metal tools. Sails were added and larger boats were built by hollowing several logs and pinning them together. As large trees became scarce, up to nine logs might be incorporated. Bugeyes, sleek two-masted oyster boats, were originally dugouts with plank sides added above the hull. Eventually, more expensive, plank-built boats eclipsed those hewn from logs. Cambridge Creek was a natural site for boat building and the post–Civil War building boom developed lumber mills and attracted some of the Chesapeake Bay region's most skilled builders. Even a few whalers were constructed there for New Englanders. During World War II, Cambridge Shipyard turned out vessels for the military and attracted skilled down-County boat builders to town, some of whom were descended from native people.

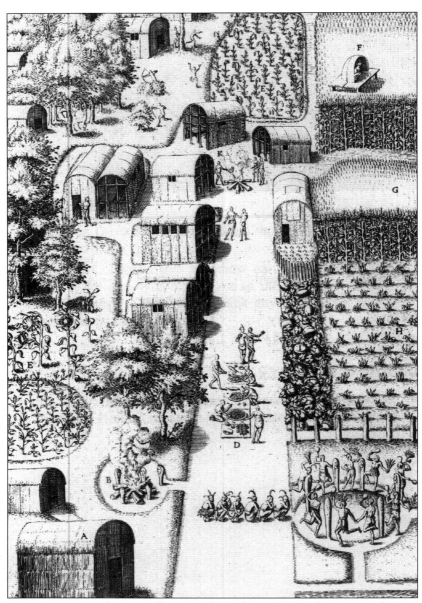

This European engraving depicts villages such as those observed in secure locations. More exposed villages were protected by log fortifications. These earliest no-till farms yielded corn, grain, squash, and tobacco, planted with pointed sticks and fertilized with fish. When corn was ripening, the domed shelter near the field concealed youngsters responsible for shooing birds off the succulent kernels. A wide avenue allowed public gatherings. Extended families sheltered in quonset-shaped longhouses with reed panels that were raised or lowered according to the weather. Hewn furnishings and a hearth fire provided comfort, while animal skins provided warmth. The Choptank River Indians were akin to the Nanticokes, members of the Algonquin language group. They loved travel and traded along the waterways of the Chesapeake Bay and beyond. There was no concept of "private property;" the idea of owning land was foreign to the Indians.

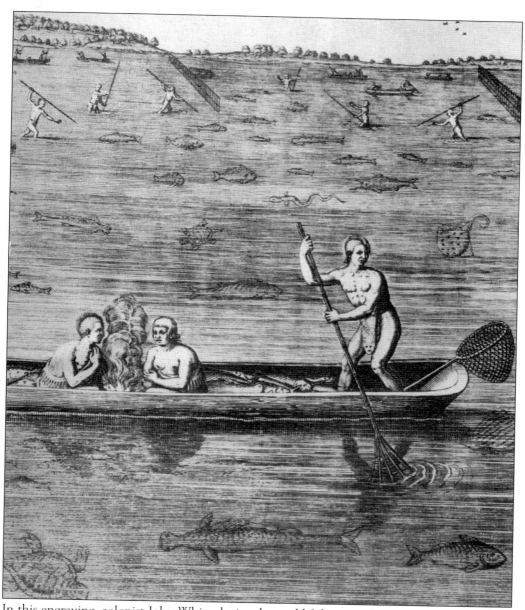

In this engraving, colonist John White depicted age-old fishing methods of the "New World." Many Indian practices were adopted by settlers. Some are practiced still, though most were banned in recent years. The stake nets in the background are not allowed by the Department of Natural Resources, nor is it legal to attract fish by illumination, as shown by a fire burning on a hearth in the canoe. Impaling fish with spears tipped with horseshoe crab-tails never caught on with the newcomers. Colonists improved on the rake being used in shallow water to harvest oysters. They fashioned metal tongs with opposing heads, worked scissor-like by long shafts pinned together. This allowed them to rake together oysters in deeper water, close the heads by closing the shafts, and raise them hand-under-hand into their workboats. Tongers worked well into the 20th century from hewn-log workboats they called canoes, pronounced "kun'ers," which were originally propelled by sail, and later by one-cylinder gasoline engines.

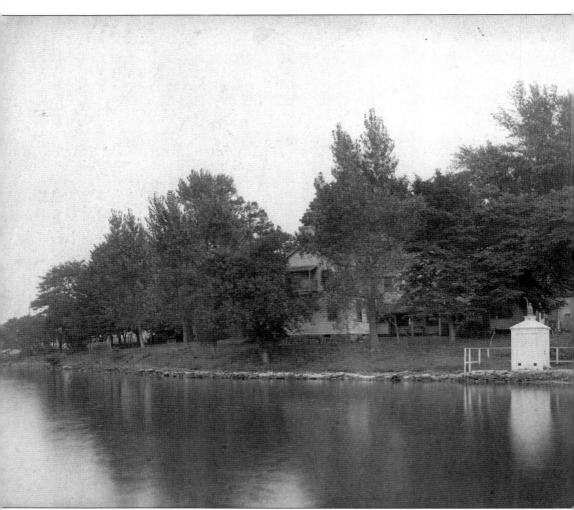

Viewed here from Cambridge Creek, "The Point" was considered Cambridge's oldest dwelling. Located just inside Cambridge Creek adjoining a grassy common at the end of High Street, one room was said to have been built by John Kirk(e) around 1710, an assertion some historians dispute. Primary records indicate John Kirk acquired the site from the Indians in a series of trades, but had established himself on Shoal Creek before 1706. Cambridge was first surveyed in 1684, but the area did not thrive until it was re-surveyed in 1706. The Point's property consisted of five lots laid out in 1706. Kirk retained Lots 1 and 2, which seemed not to contain a dwelling when sold in 1734. In any case, Charles Goldsborough lived on Lot 3 by the mid-1730s and subsequently acquired all five lots. The house later was associated with other prominent names, including Steele, Eccleston, Hayward, and Sulivane. When temporarily unoccupied in the early 1900s, it was suggested as an ideal site for a public park. Instead, the house was razed in the 1930s for industrial use, but the interior paneling was salvaged and removed to Cincinnati, Ohio.

Great Choptank Parish dates back to the time when the Anglican Church became an official body authorized to levy taxes. Christ Church was built on three acres given to the Parish. The American Revolution brought a separation of Church and State and an Episcopal Church independent of England. This Christ Church is the third in Cambridge, consecrated in 1892 to replace one lost to fire. The Gothic structure glows with stained glass, including a window by Tiffany.

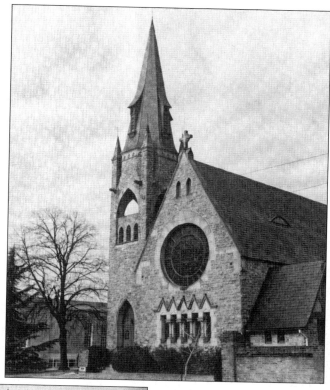

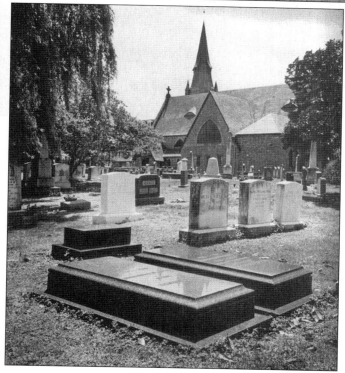

Many Dorchester notables rest in Christ Church Cemetery. Some were relocated here when outlying cemeteries became neglected. Tombstones attest to many heroes enfolded within the old red brick wall. Many gravesites are lost to history. William Vans Murray, Hon. Robert Goldsborough, and uncountable others are believed to be buried in the church yard, some in the old burial ground under the present church.

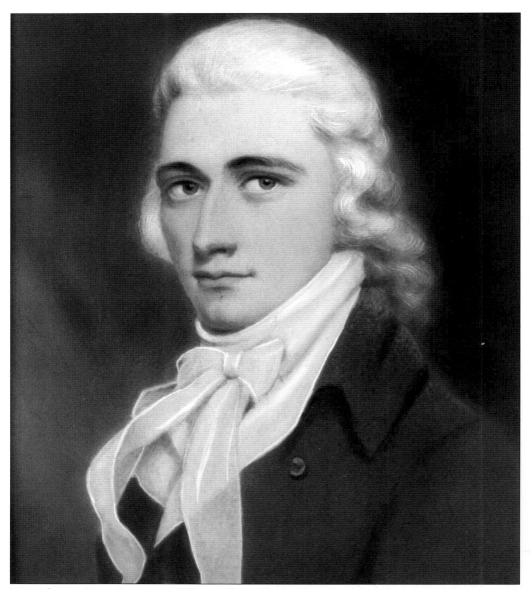

Maj. Thomas Muse Sr. was one of many from Cambridge who served during the Revolutionary War. He gazes on the world here with equanimity, but lost his life during turbulent 1776, shortly after being commissioned in the 19th Battalion of Militia and assigned to recruiting by Maryland's Council of Safety. With support for the Declaration of Independence far from unanimous, recruiting at public gatherings was a lightning rod for passionate debate. Muse's militia unit served near home, but also supplied troops to various Continental Army units under Gen. George Washington. The Sixth Independent Maryland Company with Capt. Thomas Woolford commanding was a locally-recruited unit posted in Cambridge in 1776 before joining other forces of the Maryland Line in New York. Defeated in the Battle of Long Island, the Maryland Line suffered severe losses in Washington's most discouraging encounter with the British. Another unit recruited locally that fought under Washington was known as the Flying Camp, Capt. Thomas Bourke commanding.

The Rev. Freeborn Garrettson (1752–1827) brought Methodism to Dorchester County in 1780. An Englishman, he arrived amidst the Revolution proposing reforms in religious practices, unnerving patriots and clergy alike. Imprisoned, he ultimately converted many of his captors. Methodists observed the centennial of his arrival in 1880 at a celebration uniting, in the words of the time, "Zion ME Church, Zion ME Church (Colored), ME Church South and African ME Church."

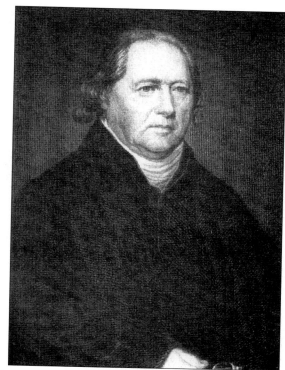

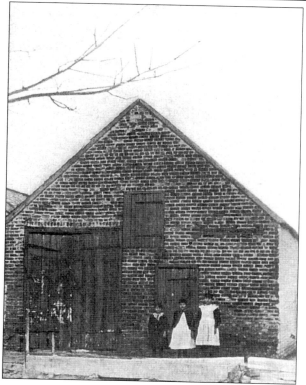

The Rev. Freeborn Garrettson was imprisoned in this Locust Street jail, captured by a gang of ruffians incited against his preachings. He was to be confined 12 months awaiting trial, but won release after two weeks of sleeping on bare ground with his saddlebag for a pillow. The jail later served as a stable and housed the fire company's hand-pumper. Around 1885 it was dismantled and its bricks donated to the church and sold for $1 each.

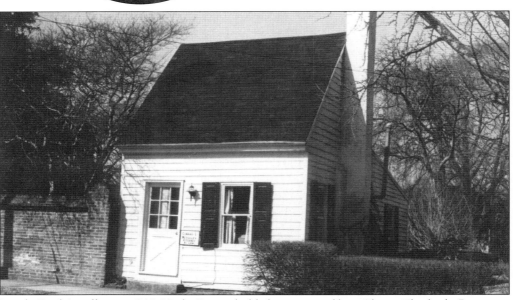

Josiah Bayly (1769–1846), a skilled lawyer, lived and practiced on High Street near the Courthouse, on land purchased from Christ Church's original parcel. His practice served famous and infamous figures of the day. A Federalist, he served 15 years as Maryland's Attorney General, from 1831 to 1846. He is buried in Christ Church Cemetery, which adjoins his home and office.

Josiah Bayly's office at 213 High Street held fascinating files. Client Elizabeth Patterson Bonaparte, jilted by Napoleon's youngest brother Jerome after marrying and having his son, maintained until her death at 95 that her son was rightful heir to France's throne. Client Patty Cannon was a notorious slaver, thief, and murderess. Patty died imprisoned and Elizabeth's son never reigned, but her grandson did go on to serve as Theodore Roosevelt's Attorney General.

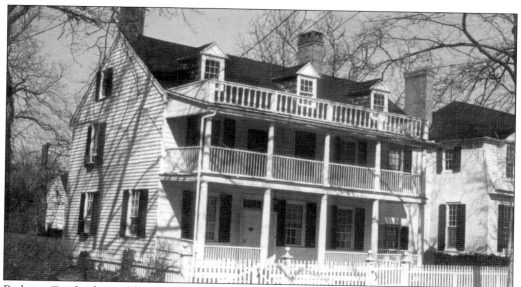

Perhaps Cambridge's oldest surviving house is 207 High Street. The house was probably built around 1755 in Annapolis. Its owner, John Caile (Caille), leased part of three acres laid out for Christ Church, dismantled, shipped, and reassembled his frame house near the Courthouse, where he was clerk. For many generations it has belonged to Bayly family members, who added porches and the brick portion. Dr. Alexander Hamilton Bayly, Josiah's son, cultivated a famous garden behind the house.

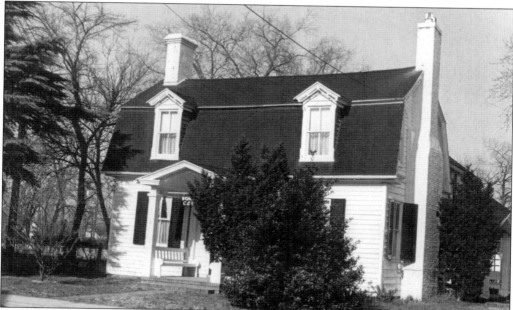

Sycamore Cottage originally stood in a grove of sycamore trees at 116 High Street, near Christ Church. It served as Christ Church Rectory during the ministry of the Rev. Daniel Maynadier Jr. from 1765 to 1772. In 1840, the former rectory was divided and this portion was moved to 417 High Street. Since 1922, it has housed the Cambridge Woman's Club, sponsor of many projects for the enrichment of Cambridge.

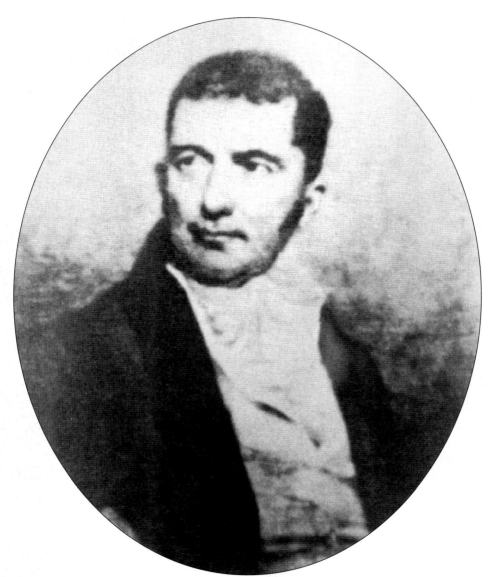

The Hon. Charles Goldsborough (1765–1834) of Shoal Creek was governor of Maryland in 1819, and the last member of Alexander Hamilton's conservative Federalist Party to hold the office. Like many other Goldsboroughs, he was a distinguished jurist and congressman. His roots in America date from the earliest days of Dorchester, Queen Anne, and Talbot Counties, but the Goldsborough family is one of the most ancient of Saxon England, with land grants dating back to William the Conqueror. The American branch of the family originated with Nicholas Goldsborough, who left Dorset, England, in the latter 1600s and settled on Kent Island, after stopping at Barbados and New England. The future Governor Goldsborough was just a youngster in 1776, but the family was represented on the Maryland Council of Safety and in the debates swirling around the Revolution, living up to their motto, *Non Sibi*, Not For Self. The Governor's estate "Shoal Creek" is memorialized only with a shopping center of the same name near its former site, but his stable was rescued by the Dorchester County Historical Society.

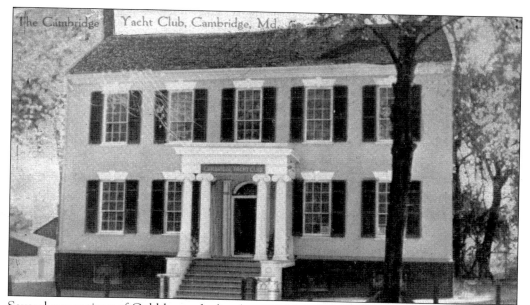

Several generations of Goldsboroughs lived at 200 High Street, which was built around 1790. Charles Goldsborough, who was one of the earliest residents, sold the house in 1800 for the then-imposing sum of $4,000. Goldsborough went on to serve in the U.S. House of Representatives and as governor of Maryland. The Cambridge Yacht Club was located here from 1910 to 1918 and held dances in a pavilion behind the house near Cambridge Creek.

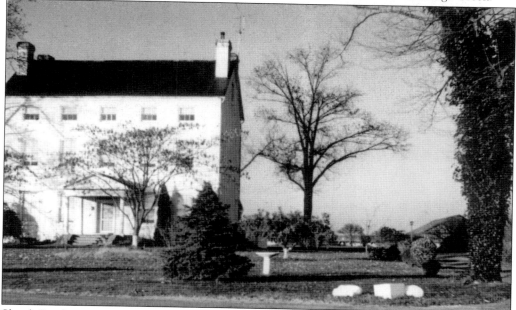

Shoal Creek was once a 378-acre plantation boasting a three-story, brick manor house whose owners included John Woolford and Gov. Charles Goldsborough. The 16-room dwelling survived until 1970, accumulating tales of hauntings, secret passages, and buried treasure during its 200-year existence before being razed to make way for expansion of the city's wastewater treatment plant.

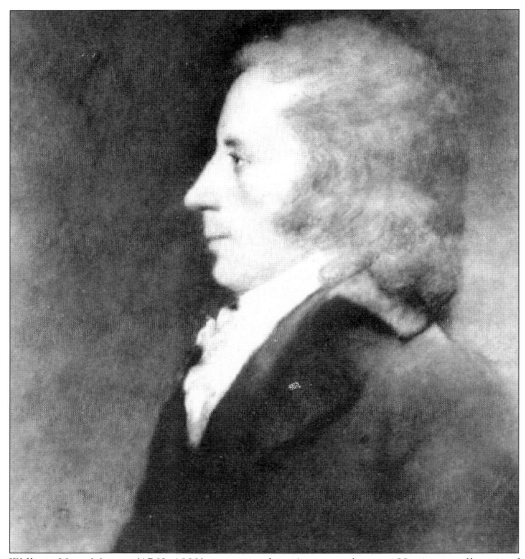

William Vans Murray (1760–1803) was pivotal in American history. He was a colleague of Presidents George Washington, Thomas Jefferson, and John Adams. At Jefferson's request, in 1792 he recorded vocabulary from the few native-speakers remaining on the river at Locust Neck, north of Cambridge. These findings were only recently published. In 1797, President George Washington appointed him Minister to The Hague. When emissaries dealing with France's wily Foreign Minister Talleyrand met with a $200,000 bribe request, President John Adams outraged Congress by sending young Murray to deal with Napoleon's seasoned minister. In addition to misgivings about Murray's youth, Congress was eager for a fight with France. Murray's mission averted war and culminated in the Convention of Mortefontaine, paving the way for lasting peace and the Louisiana Purchase. Treating with the French may have cost Adams a second term as president, but he considered the treaty Murray negotiated his crowning achievement. Adams wanted it memorialized on his tombstone that "he took upon himself the responsibility of peace with France." Murray, never robust, died shortly after returning to Cambridge.

The present Waugh Chapel United Methodist Church, built in 1901, replaced earlier structures dating back to 1826, when the congregation separated from Zion Church, making it the oldest African-American and second oldest Methodist congregation in Cambridge. Jenifer School was located next door on land titled to Hester Anne Jenifer, a free woman. Her husband, Benjamin Jenifer Sr., minister, educator, Zion Church sexton, and slave of Josiah Bayly, could not then legally own property.

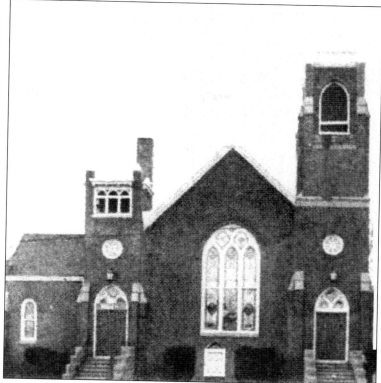

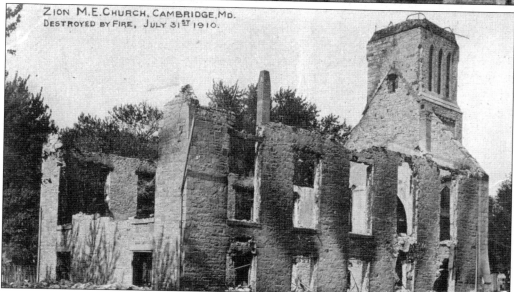

Cambridge Methodists undertook in 1800 the task of building a house of worship at Church and Mill Streets to be known as Zion Chapel. In 1845, the cornerstone was laid for a larger, stone church in the 400 block of Race Street, which was in the path of the great fire that destroyed much of the downtown area. Zion Church was then rebuilt at Locust and Mill Streets.

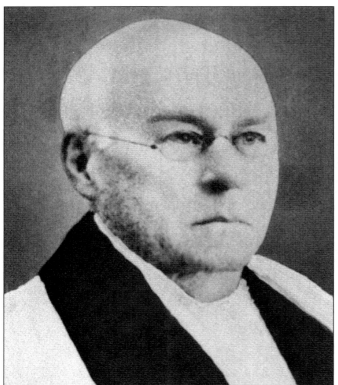

The Rev. Theodore Philip Barber (1822–1892) served as rector of Great Choptank Parish for 43 years. The present Christ Church was erected under his guidance. He was the only Episcopal clergyman in the vast expanse of Dorchester County when he arrived in 1849. His missionary spirit led him to build or resurrect and staff churches or chapels at East New Market, Vienna, Church Creek, Taylors Island, Cornersville, and Maple Dam Bridge.

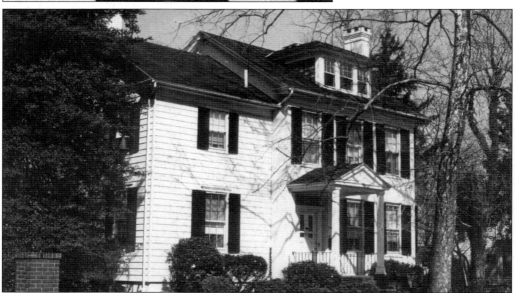

Sarah Y. Goldsborough, widow of Gov. Charles Goldsborough, donated a building lot at 107 High Street for construction of a rectory in 1849. The completed house was rented until 1858, when the mortgage was repaid and Reverend Barber and his family took up residence. He lived here until his death. Reverend and Mrs. Barber and their sons, aged six, two, and four, are buried beside the church.

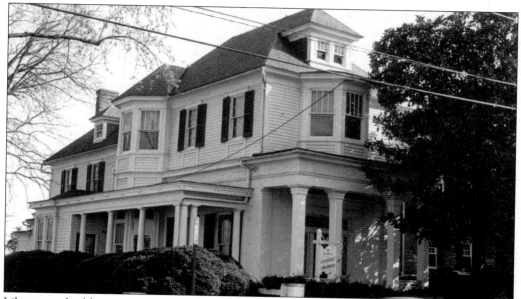

Like many buildings near the courthouse, 202 High Street originated as a law office. At one time, an attorney was required to locate his office and residence together. James A. Stewart built a law office at 202 High in 1848 when he acquired the house at 200 High. Later both were sold to Judge Charles L. Goldsborough. Noted architect and builder J. Benjamin Brown expanded 202 High Street in 1919 to accommodate his residence.

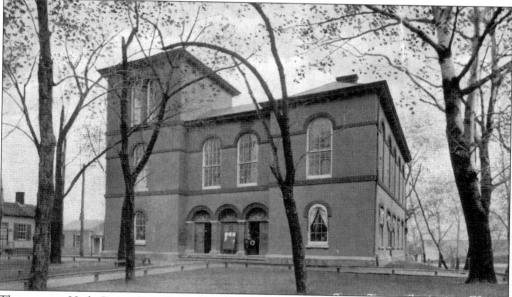

The current High Street Courthouse is at least the sixth building to serve Dorchester County since its creation, the fourth in Cambridge. The original Cambridge site at the northeast corner of what is now High and Locust Streets had served as both courthouse and house of worship by 1695. Before 1719, a courthouse had been built around the present site, which was replaced in 1770 by a brick structure. In 1852, a suspicious fire destroyed the brick courthouse, along with many of the historical land records it contained. The new courthouse was completed in 1854.

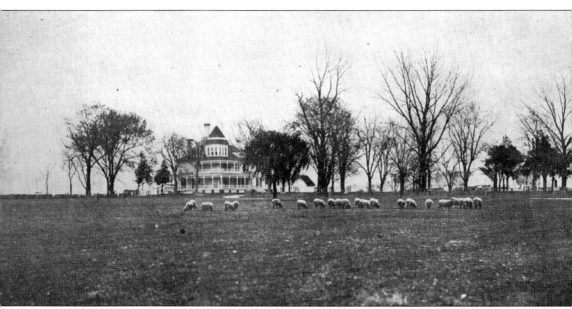

Appleby was a 300-acre tract purchased from the Indians of the Choptank River in 1726 by Henry Ennalls for 22 pounds of tobacco. The house evolved through various owners until Gov. Thomas Holliday Hicks remodeled it into a Greek-revival style manor after acquiring it in 1858. At that time, the estate was largely intact and located on a shell road leading from town to Church Creek. The house sat well back up a lane curving across a meadow where sheep kept the acreage in trim. When this picture was taken around 1900, the estate still contained 250 acres and was owned by W. Lake Robinson, who was an officer or director of the following: Cambridge Creamery; Farmers & Merchants Bank; Cambridge Manufacturing Co.; Cambridge Gas Co.; Robinson & Barnett brick manufacturers; Robinson & Dail coal and wood; and Robinson & Wright, insurance. He was also an originator of Cambridge Telephone Co., Chairman of the Democratic State Central Committee, and served a term as sheriff, as had Governor Hicks. In the mid-1950s, the land was totally sub-divided and developed; the house was remodeled into apartments.

Thomas Holliday Hicks (1798–1865), governor of Maryland from 1858 to 1862, was responsible for holding the state in the Union during the Civil War. Secessionist sentiment divided the community and necessitated an army of occupation and naval patrols to enforce the draft and prevent smuggling of supplies and enlistees to the South.

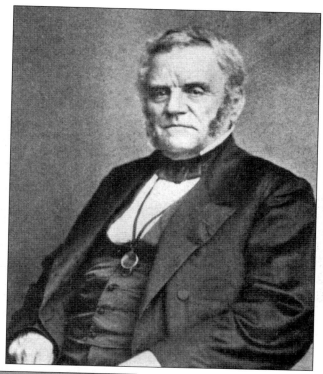

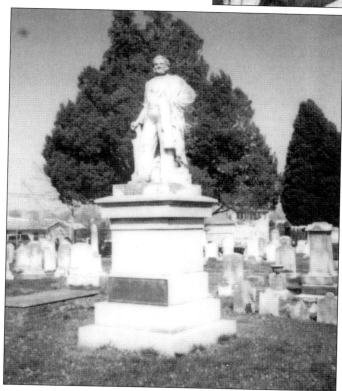

Governor Hicks, the only Cambridge resident honored with a statue, has this State-erected likeness and plaque in Cambridge Cemetery honoring "a native and life resident of Dorchester County. Late in 1860 and early in 1861 . . . he opposed the doctrine of secession and of coercion. In furtherance of his policy and resisting great pressure, he refused for five months to call the legislature in special session. During the war he supported the Union."

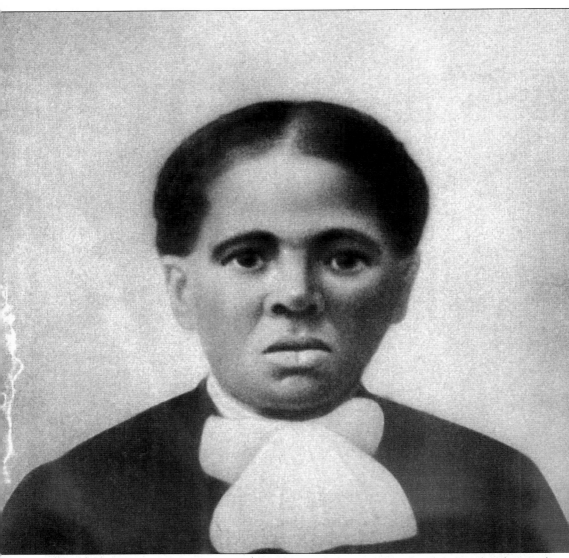

Harriet Ross Tubman (1820–1913) inspires many visits to Cambridge due to valor that made her "Moses of Her People." Born into slavery in a marshy area below town, she returned repeatedly after escaping in order to lead family and others along the Underground Railroad, a secret route leading northward from slavery to freedom before the Civil War. Using railroad terms as code, travelers on the Underground Railroad did not glide effortlessly along an established route. They faced unknown perils and relied on the kindness of strangers while crossing unfamiliar terrain afoot or by skiff. Progressing northward, they received shelter and provisions at various "stations," homes or churches of supporters. The Underground Railroad is credited with carrying 75,000 from slavery to freedom and Harriet Tubman was its most celebrated conductor. When the Civil War broke out, she further risked her freedom as a scout and nurse for the Union Army. After settling in Auburn, New York, she opened her home to elderly, needy blacks and worked for women's suffrage, which she did not live to see.

The house at 118 High Street, built around 1790 at the turn of the 20th century, was the home of Ivy L. Leonard. His oyster-packing house and tomato cannery were located on Cambridge Creek behind the house, where the County Office Building property is now located. He was also senior partner in I.L. Leonard & Sons, located at 21 Race Street, the largest dealers in "shoes, hats, caps and gents' furnishings" in Cambridge.

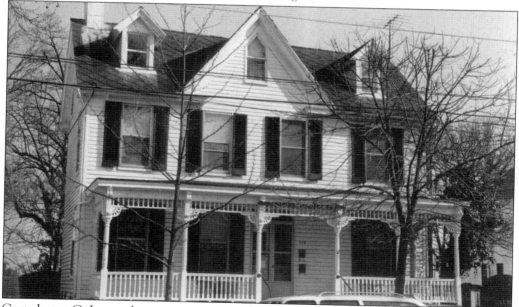

Capt. James C. Leonard, oysterman and brother of Ivy, operated Leonard House, a hotel for passengers and officers arriving in the harbor aboard steamboats and sailing vessels. Formerly, 118 and 120 High Street was a single 20-room house that was split. The dwelling at 118 High was moved several yards to its present location. The gift shop, gallery, and studios of the Dorchester Arts Center are now housed at 120 High Street.

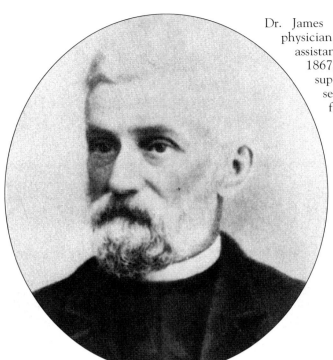

Dr. James L. Bryan (1824–1904) was a physician, educator, and minister. While assistant rector of Christ Church in 1867, he was appointed the first superintendent of schools and served for 32 years. He championed free textbooks for students. On visits to classrooms his grand entrance was sometimes marred by children leaving a coal shovel where he might trip.

The original Academy School was incorporated in 1812 as a private or "pay school." Earlier, parents with the means had their children taught by tutors, often indentured servants unfit for manual labor. Existing private schools such as the Academy School and the Female Seminary were gradually absorbed into the public school system established in Maryland for whites in the 1860s and extended to blacks in the 1870s.

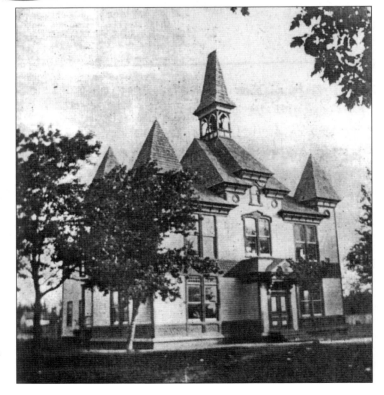

Two
THE OYSTER BOOM

Cambridge grew rapidly following the Civil War. A channel was dredged, admitting steamboats beyond Castle Haven. A new railroad linked Cambridge to Seaford and markets beyond. The initial demand was for oysters from the rich beds of Choptank River and nearby Chesapeake Bay. Col. James Wallace (1818–1887), a lawyer by training, returned from the Army of the Potomac and opened Cambridge's first full-scale oyster cannery. The Colonel's office stands on "The Hill," which is now library property at Gay and Spring Streets. From this vantage point, Colonel Wallace could see oysters being tallied at his packinghouse at the foot of The Hill as the catch was ferried in and unloaded from buy-boats. Colonel Wallace, a gifted orator, is credited with helping get the channel dredged to admit steamboats to Cambridge, establishing a municipal water system, and generally promoting sobriety and progress in the city. The Colonel's son James (1850–1903) further expanded the firm James Wallace & Son, canning fruit and vegetables under the brand names "Abbsco" and "Pride of Cambridge."

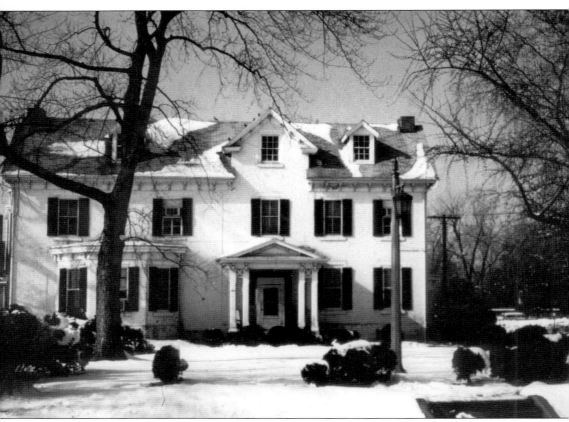

Col. James Wallace's mansion stood on the high ground above the courthouse known simply as The Hill. The house's origins pre-dated the Colonel's Civil War battles, and the American Revolution as well. Two graves survive on the property: John Woolford, who died in 1773 at the age of 70, and his wife Margaret who died a year earlier. Colonel Wallace, a student of history, was chief marshall of the parade held on July 4, 1884, in celebration of Cambridge's bicentennial and the speech he delivered is still reprinted and quoted. The Wallace family owned the property for 70 years after acquiring it in 1838, and Colonel Wallace and his wife Emma raised their son James Jr. and daughter Katherine there. When E.L. Hooper later operated the Hotel Dixon to the rear, he lived in the mansion and sometimes housed an overflow of clients there. The City of Cambridge bought the mansion in 1940. It housed the Health Department before it was razed to make way for the Dorchester County Public Library.

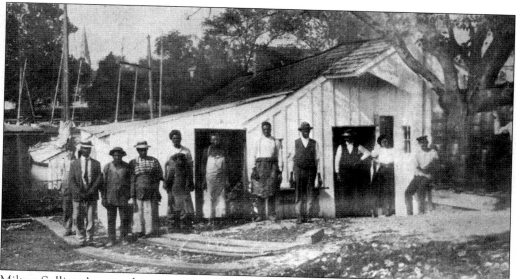

Milton Sullivan's oyster house typified those that lined Cambridge Creek. Above, he stands in the doorway amidst his workers at the shucking plant on Trenton Street. The plant was located near the east end of Cambridge Creek Bridge. When photographed around 1908, he already had 25 years of experience in the oyster business. The Sullivans later operated a chandlery across the bridge on Market Street, supplying captains and crews of oyster boats with their weekly provisions.

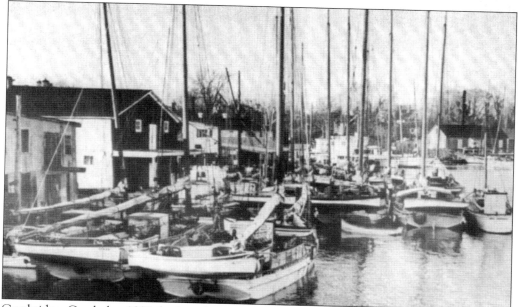

Cambridge Creek by 1890 harbored 700 to 800 oyster boats. Pungies, bugeyes, bateaux, schooners, and skipjacks left weekly to dredge under sail. Small workboats called canoes (kun'ers) went out each day with one or two aboard to tong shallow-water beds. On the weekends, boats rafted together, a forest of masts rising and raking at different angles. Lumberyards, boat builders, sail makers, ship chandlers, and marine railways built and maintained the fleet.

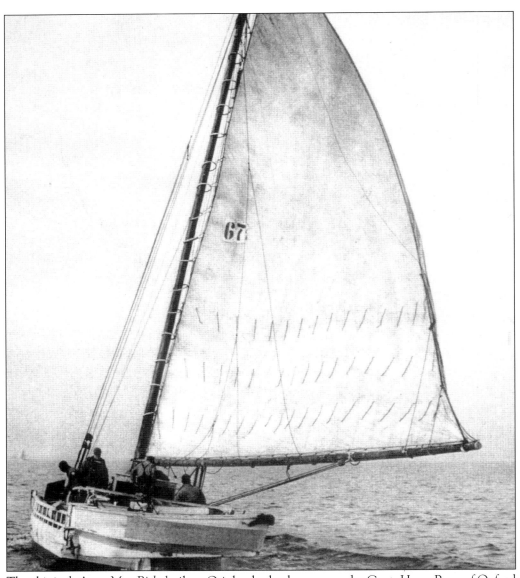

The skipjack *Anna Mae Rich*, built at Oriole, dredged oysters under Capt. Harry Pope of Oxford before it was bought and relocated to Cambridge by Capt. Charles W. Todd. Skipjacks replaced larger boats such as bugeyes, formerly the workhorses of the oyster fleet. Skipjacks were cheaper to build and simpler to operate, requiring fewer crew. Their shallow draught and centerboard design allowed sailing where their predecessors could not, and eliminated the need for ballast. Before skipjacks, packinghouses loaded shucked-out shell aboard as ballast, to be put overboard when the catch supplied weight. This automatically kept oyster beds supplied with shells needed for next season's spawn to attach. As skipjacks replaced older boats, shell conservation laws were enacted. Legislation requiring dredging under sail rather than power preserved the skipjacks themselves as the nations last commercial sailing fleet. In her final days, the *Anna Mae Rich* awaited conversion to a yacht by Jim Richardson on LeCompte Creek when her new owner died. In a clean-up drive, the State burned her, along with the sloop *Henry W. Ruark*, built in 1884 at Taylors Island.

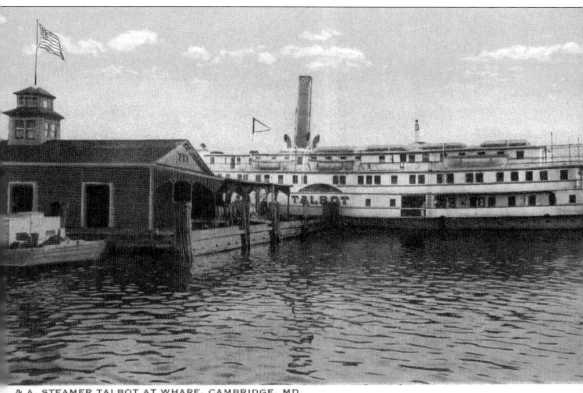

& A. STEAMER TALBOT AT WHARF, CAMBRIDGE, MD.

The steamboat *Maryland* entered the Choptank River in 1830, but steamers could not reach as far as Cambridge until a channel was dredged in 1873. Within a couple of years, shallow-draught sailing packets were out of business, replaced by reliable passenger and freight lines independent of prevailing winds. By 1883, four steamboat companies called regularly. The Baltimore, Chesapeake and Atlantic Railroad Company eventually consolidated several lines and operated the wharf and freight houses at the foot of High Street. Miss Nellie Marshall in 1966 recalled, "Anyone who traveled by one of those well-remembered steamboats has nostalgic memories of a pleasant trip, an excellent dinner, and listening to the singing of stevedores as they loaded produce. Their singing was often interrupted by the bleating of lambs or calves, or cackle of fowl." The fare from Baltimore to Cambridge in 1908 was $2.50, including stateroom and supper. Besides the *Talbot* pictured here, steamboats calling at Cambridge included *Ida*, *Highland Light*, *Enoch Pratt*, *Emma Giles*, *Georgianna*, *W.E. Clark*, *Joppa*, *Choptank*, and *Minnie Wheeler*.

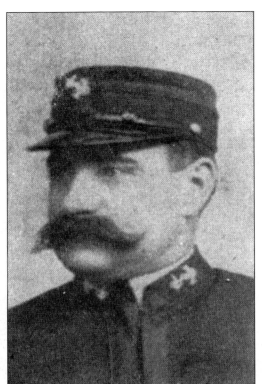

Commander Thomas C.B. Howard's initials may not have stood for Chesapeake Bay, but reputedly, he knew every inch of water that would float a boat and grow oysters. The Maryland Oyster Navy originated in 1867 to counter "wholesale piracy . . . by dredging boats from other States." On December 10, 1888, Howard's force fought a pitched battle with about 50 outlaw dredge boats, routing the miscreants and earning him a hero's welcome in Annapolis.

The Oyster Navy's most formidable weapons against piracy were the steamboats *Governor Thomas* (shown here) and *Governor McLane*. The boats had plated pilothouses and were armed with howitzers and crews with Winchesters. Virginia had a similar force. Oyster beds along an unresolved boundary brought the two forces to a face-off in which a number of lives were lost. The *Governor Thomas* was dispatched from the Choptank to protect Maryland watermen working disputed oyster beds.

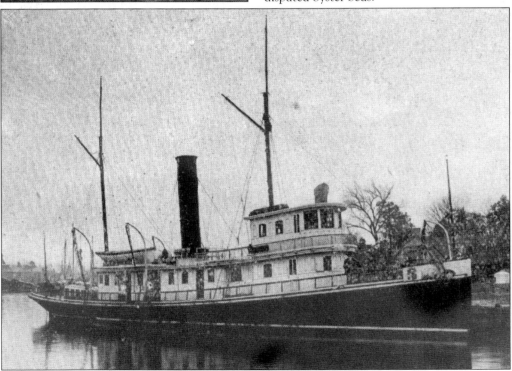

Sarah C. Conway was originally in a fleet of schooners owned by Capt. Harvey Conway. Legend has it Captain Harvey came to Cambridge from Puckum with only the clothes on his back, wearing a boot on one foot and a shoe on the other. The fortunes then possible in oysters were such that he ultimately owned a fleet of six such schooners, one for himself and each son. *Sarah's* subsequent owner, Capt. C. Calvert "Cat" Evans, freighted under sail, carrying cargo over Chesapeake Bay. Like most seaworthy schooners, *Sarah* was eventually converted to power, however reluctantly. Under sail she was at the mercy of the wind and unable to compete with gasoline or diesel-powered freighters. In latter days, many buyboats shuttling oysters from dredge boats to packers were dieselized schooners, their masts removed, and a pilothouse added. When Captain Evans bought *Sarah*, he discarded trailboards reading *S.C. Conway* and had new boards made. Before long, the *S.C. Conway* boards appeared in the Mariners Museum in Newport News, Virginia.

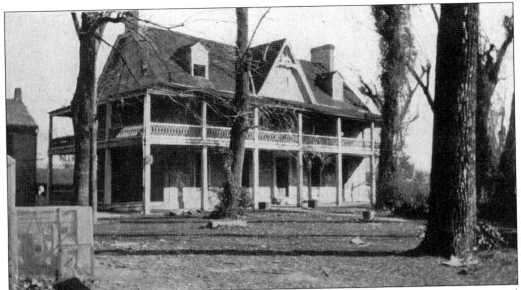

Straughn Mansion, erected in the 1700s, housed Sen. Gustavus Scott of the Continental Congress, who employed young Josiah Bayly. The mansion became Dorchester House in the 1800s, a hotel hotbed of Democratic Party activity. Guests of another persuasion were in for it, as orators held weeklong debates on the lawn. After a long, colorful life at Gay and Race Streets, it was razed in 1936 and replaced by a car dealership.

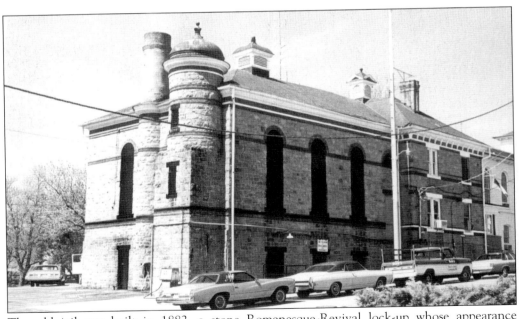

The old jail was built in 1882, a stone Romanesque-Revival lock-up whose appearance emphasized its mission, but whose local familiarity softened its image. When it was demolished in 1993 to accommodate expansion of the courthouse, it sparked a firestorm of preservationism previously unseen in Cambridge. Many admirers, and possibly a few former tenants, salvaged souvenir masonry from the demolition.

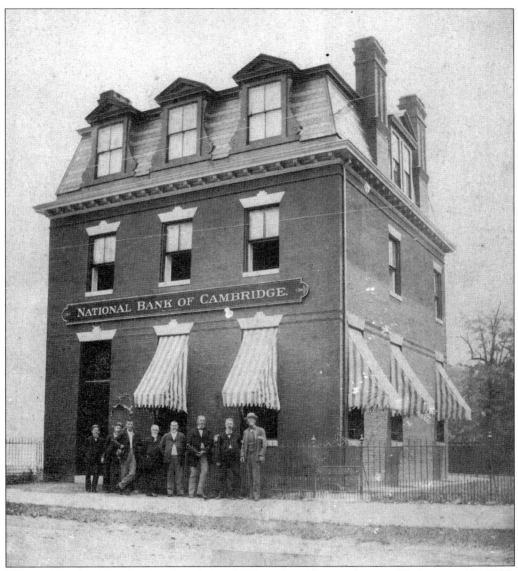

National Bank of Cambridge, founded in 1880, is the oldest in the city. On January 17, 1880, The *Cambridge Era* reported, "The prospect of a bank is hourly becoming more encouraging." Readers were encouraged to contribute capital so "the question of a bank in Cambridge will be forever settled." With capital stock of $50,000, it operated a year in the sheriff's office. The above structure burned when the fire of 1892 destroyed most of the 300 block of High Street. Newspaper reports assured the public that, when the vault was opened, "books, coins, and other valuables were elegantly preserved and nothing was harmed." Bank president William Barton, fourth from left, was a Naval Academy graduate and Civil War veteran. He conducted business from his office until the present Romanesque-style building was completed at 304 High Street. The new building was designed by J. Benjamin Brown in brick and granite. During the Great Depression, the bank was the only one on the Eastern Shore to do business as usual throughout, paying dollar for dollar to depositors. Others repaid customers in chits, to be redeemed later at reduced rates, if at all.

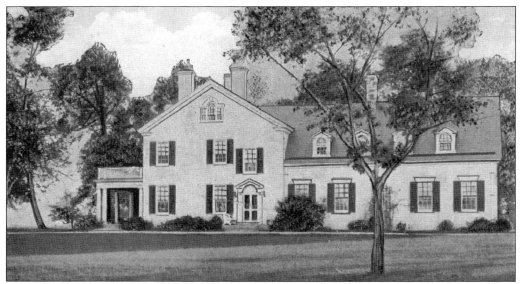

Glasgow was birthplace of William Vans Murray Robertson, named in honor of his uncle, William Vans Murray. Mr. Robertson dropped his last name in 1821 and has forever after been confused with his mother's brother, the diplomat. The 800-acre estate, originally called Ayreshire, was purchased in 1840 by Dr. Robert F. Tubman. Dr. Tubman divided it between two sons into Glasgow and Glenburn, and it has since been sub-divided countless times.

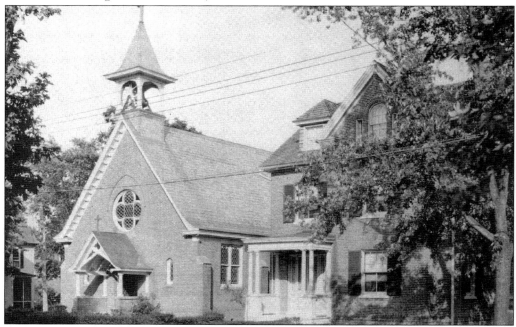

Catholics celebrated mass from the 1840s to 1880s at Dr. Robert F. Tubman's manor house chapel at Glasgow, and later downtown in Independence Hall. St. Mary's Refuge of Sinners, built in 1894 at William and Mill Streets, accommodated a growing Catholic population. The rectory to the right was built shortly thereafter. The modern church, rectory, and Minnette Dick Hall on Hambrooks Boulevard occupy a site that was once part of Dr. Tubman's estate.

Gothic-style Bethel AME Church replaced a structure which had burned shortly after the Civil War. In a leap of faith, the congregation began erecting this brick church on the ashes of its predecessor. Despite hard times, they completed what an 1880 newspaper hailed as the "handsomest church in town." In 1903, a facade with stained glass windows and two towers completed what is known as "The friendly church with the open door."

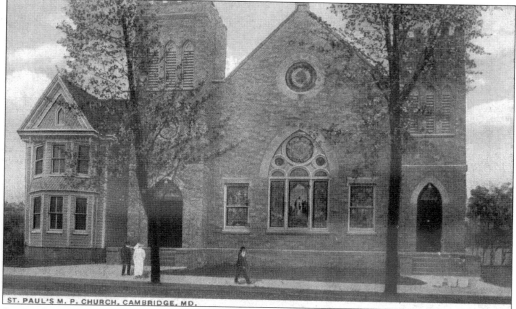

ST. PAUL'S M. P. CHURCH, CAMBRIDGE, MD.

St. Paul's UM Church is a handsome granite building completed in 1913 at 205 Maryland Avenue in East Cambridge. The parsonage shown on this postcard was replaced by the Fellowship Hall in 1979. The present church replaced a frame structure built in 1882, but the congregation dates back to 1843.

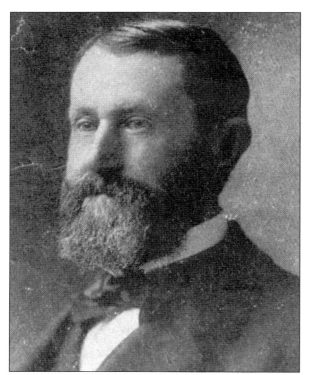

J. Benjamin Brown (1849–1922), left school at 13 and apprenticed as a shoemaker, then a carpenter. At 19, he bought a Cambridge lumbermill, then began to design as well as construct buildings. He designed and built Cambridge National Bank, the Masonic Building, Cambridge Academy, Grace ME Church, other commercial buildings, and homes for Cambridge's leading citizens. Brown was the first mayor elected under the 1882 charter. He served two terms but declined more.

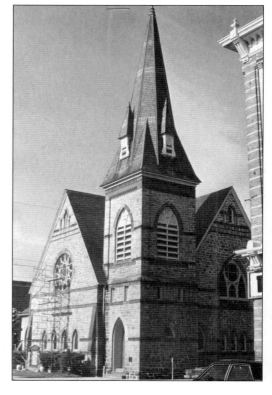

Grace ME Church is a handsome Victorian Gothic Revival–style stone structure designed by J. Benjamin Brown. When completed in 1882, its Race Street location was a residential neighborhood. The congregation, once known as Grace Methodist Church (South), formed in May 1863 from differences on issues of the time, long since resolved.

The Hon. Henry Lloyd (1852–1920) was a natural choice to succeed to the statehouse when Gov. Robert M. McLane resigned in 1885. Related to the Henrys of Dorchester County and the Lloyds of Wye House in Talbot County, both his parents were descended from Maryland governors. His mother was descended from Gov. John Henry (1797–1798). His paternal grandfather was Gov. Edward Lloyd V (1809–1811). He himself served from 1885 to 1888.

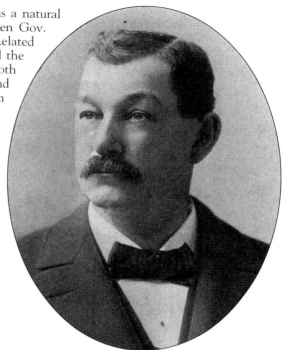

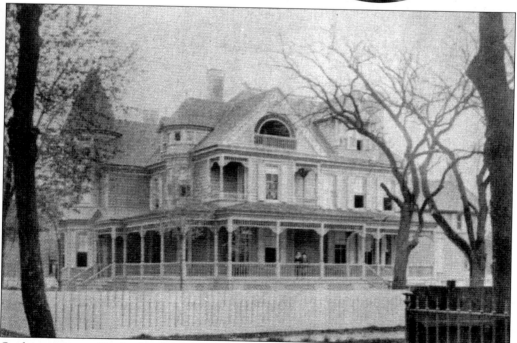

On his return to Cambridge from Annapolis, Gov. Henry Lloyd bought two acres of land at Locust and Mill Streets and had J. Benjamin Brown design this Queen Anne–style home at 701 Locust Street. The architect and his wife moved next door into the house built at 703 Locust and Lloyd's two unmarried sisters lived in the house he built for them at 313 Mill Street.

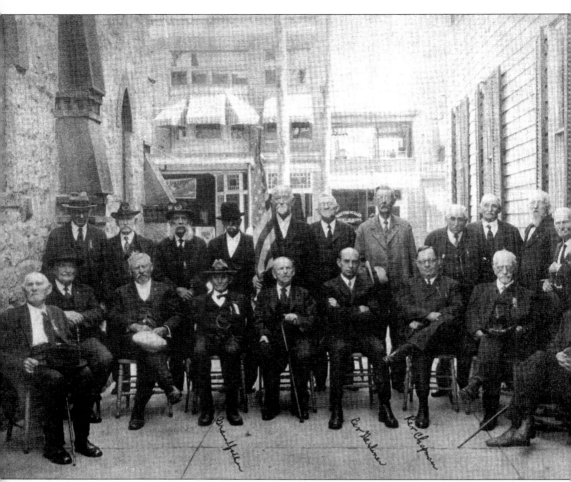

Surviving Union and Confederate Civil War veterans posed with several clergymen outside Grace Church in the 1920s. Capt. William W. Adams, seated fourth from the left, enlisted in the Union Army at the war's outbreak, and served until the end. Known to neighbors as "Captain Spunk," at age 81 he walked from Cambridge to Hoopers Island and back and said he'd often walked farther than that during the war. In July 1884, *The Chronicle* described the healing effects of the city's bicentennial on former adversaries, "after the years of fratricidal war . . . doing honor to the men who gave us the Declaration of Independence . . .doubly precious, in re-uniting in bands that can never be broken, the men who twenty years ago were divided by the horrors of civil war . . . This happy reunion first began when the soldiers who had worn the blue and those who had worn the grey went arm in arm to the sacred places where the dead of the opposing armies lay taking their last sleep, and there together laid upon the graves of the dead heroes wreaths."

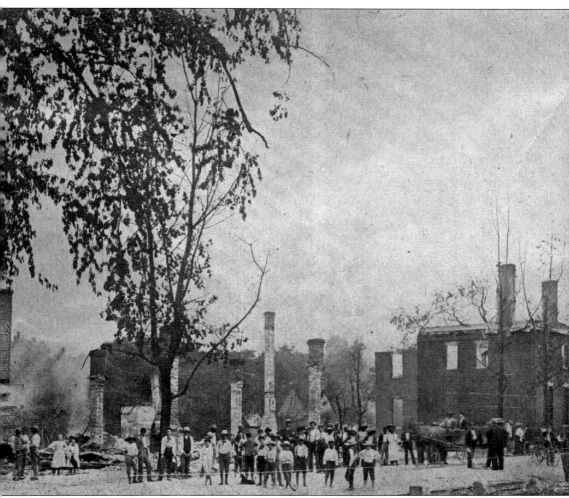

On the morning of July 30, 1892, the hayloft caught fire in Handley's livery stable behind a High Street hotel, site of the present post office. Before the blaze was contained that Sunday, fifteen buildings burned to the ground, including two hotels, two newspapers, the National Bank of Cambridge, Meyer Nathan's furniture store and home, and several other stores and dwellings. Nothing remained between the courthouse and William Fletcher's mansion, now Curran-Bromwell. Normally the fire company kept the boiler of their Silsby Steamer kindled and ready, but that Sunday it was in disrepair from an earlier fire. Further damage was averted when an Oyster Navy engineer from the steamer *Governor Thomas* jerry-rigged the Silsby and Salisbury firemen reached the scene by train in response to an emergency telegram. Many property owners and occupants lacked fire insurance at that time or were under-insured. Most of the buildings lost were frame structures and were rebuilt with brick. Photographer Charles F. Finley probably captured this snapshot of the High Street ruins.

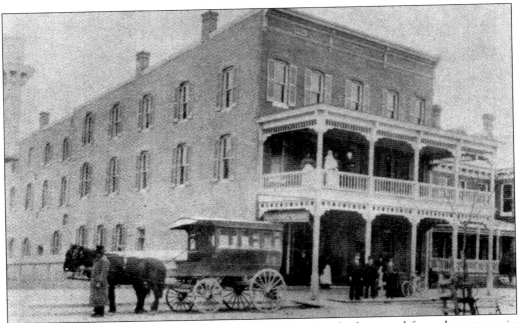

After the 1892 fire destroyed the Maryland Central Hotel and other wood-framed structures in the 300 block of High Street, manager E.E. Brayly erected Brayly's Brick Hotel, where the consumer loan building of National Bank of Cambridge now stands. Mr. Brayly advertised that his "large, attractive dining room furnishes all the delicacies of the season." In 1897, he took over management of the Dixon Hotel on the corner, later Cambridge Hotel.

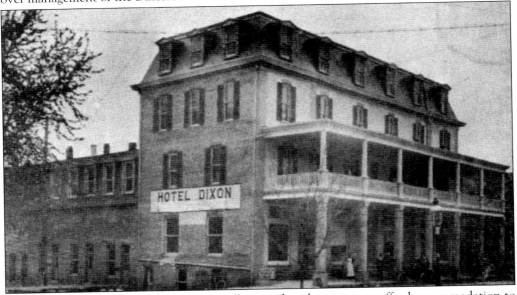

Both the Dixon and Brayly's were reportedly "taxed to the utmost to afford accommodation to the many who desire to avail themselves of a few days or weeks in the beautiful town." Dixon's lobby boasted "a colonial fireplace five-feet wide, where in season a roaring fire always burns." Sportsmen and "drummers" arrived by train and steamboat, both of which stopped calling before a bank drive-through replaced Cambridge Hotel.

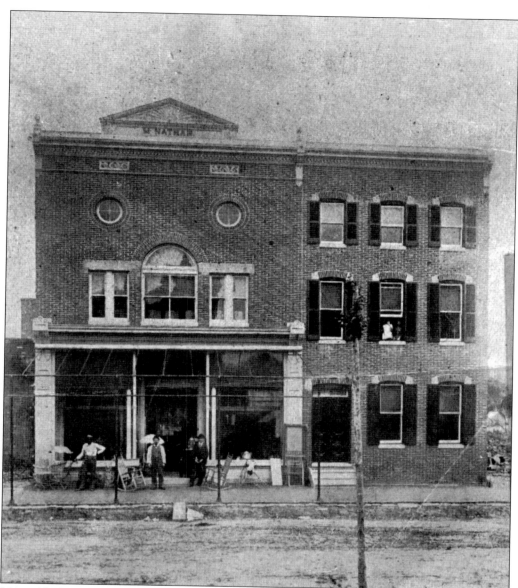

Meyer Nathan reached Cambridge around 1870, an itinerant peddler selling little necessities from a backpack door-to-door and farm-to-farm. Gradually he acquired a mule, a wagon, and within twelve years, a furniture store. *The Cambridge News* announced on April 1, 1882, "A new furniture store has been opened on High Street by Mr. M. Nathan, who will . . . sell furniture at regular city prices so that those needing articles in his line will save time and cost in buying at home." Thus, it was no longer necessary to order furniture from Baltimore catalogs to be shipped by steamer or carried home on a neighbor's schooner. Nathan lost his store and home in 1892, when even the contents of his safe were charred beyond recognition. Among those carrying insurance, he received $2,000 to rebuild. The Nathans posed for this picture around 1908 before their new furniture store and in the second-floor window of their townhouse to the right. After Meyer's death in 1911, his son Milton further expanded business into 18 stores up and down Delmarva.

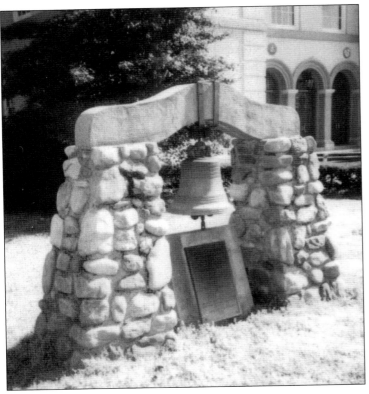

This bell on the front lawn of the courthouse, cast in 1772 and hung in a Mexican monastery, was brought to the United States during the Mexican War in 1846. It subsequently warned Cambridge of fires, hanging atop the former Colonial jail building on Locust Street when it housed the fire company's hand pump.

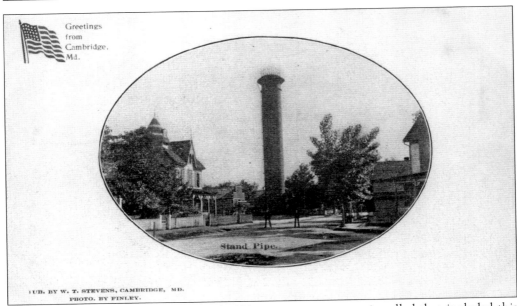

Greetings from Cambridge, Md.

Stand Pipe.

After the disastrous High Street fire of 1892, a water system was installed that included this standpipe with a capacity of 115,000 gallons. In 1909, a newspaper assured the public, "There are fireplugs at all the principal corners, pressure being sufficient to throw a stream over the tallest building."

Levi B. Phillips (1868–1945), born at Golden Hill, captained a vessel before he was old enough to vote. Oystering in season, he also sailed to the West Indies in the coasting trade. At 30, he opened a packinghouse. Four years later, he joined W. Grason Winterbottom and brother Albanus Phillips as Phillips Packing Company, canning vegetables and fruit. Levi Phillips was president of National Bank of Cambridge for 32 years.

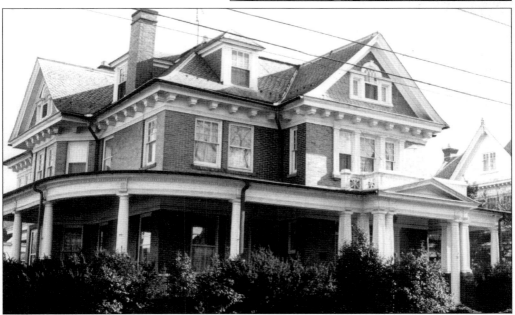

Capt. Levi Phillips had his mansion built at Mill and Church Streets in 1912 on former Zion Methodist Church property. By that time, he had diversified from wholesaling oysters as Levi B. Phillips and Co. into partnership in Phillips Packing Co., Phillips Hardware, and Phillips Can Co., among other ventures. His house, designed by Leon W. Crawford of Wilmington, combines Italian Renaissance, Georgian, and Queen Anne influences.

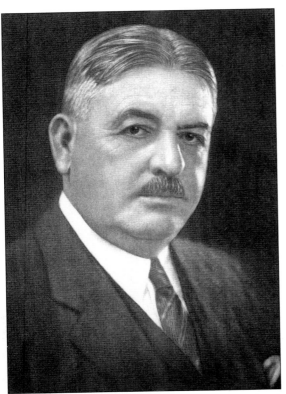

Born at Golden Hill, Albanus Phillips (1871–1949) captained his own schooner while still in his teens. He entered Cambridge's burgeoning oyster packing industry in the 1890s and along with partners Levi Phillips and Grason Winterbottom, built Phillips Packing Company into one of the nation's largest canneries. Gov. Phillips Lee Goldsborough made him an honorary colonel. Albanus and his wife, Daisy Alma, passed away within 13 days of each other.

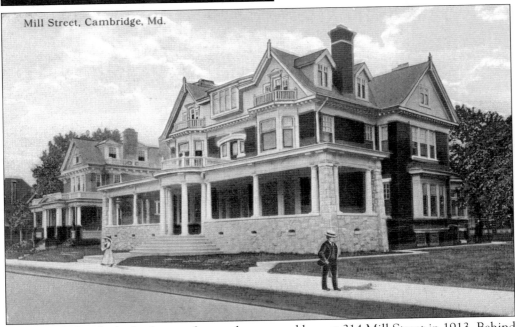

Mill Street, Cambridge, Md.

Albanus Phillips built this house of many dormers and bays at 314 Mill Street in 1913. Behind the home is the corner house of his older brother Levi. One wonders how the elder brother felt about his 22-room mansion being relegated to the background on this postcard.

Three

A NEW CENTURY DAWNS

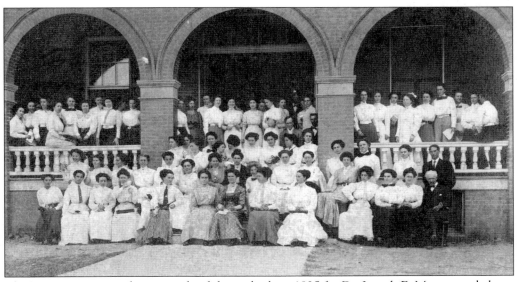

The Muse Mansion, a three-story brick home built in 1825 for Dr. Joseph E. Muse, stood above Cambridge Creek amid grounds sweeping down to the water. By the mid-1800s, it was converted to Cambridge Female Seminary, a private boarding school for young ladies. Basic tuition for a 10-week term was $6; board and washing $50; optional extra courses were French $5, drawing $5, music $12, and oil painting $12. When this Teachers' Institute was held in 1908, the Seminary had been incorporated into the public school system. By then Cambridge Academy on Mill Street had burned and the Female Seminary had become Cambridge High School, a public, co-educational school. The school stood near the west end of Cambridge Creek Bridge at the intersection of Academy, Muse, and Market Streets. After a new Cambridge High School opened on School Street in 1930, sixth and seventh grades attended here, then Phillips Hardware acquired the building. The building housed government offices during World War II. In 1955, is was razed and replaced by a gas station.

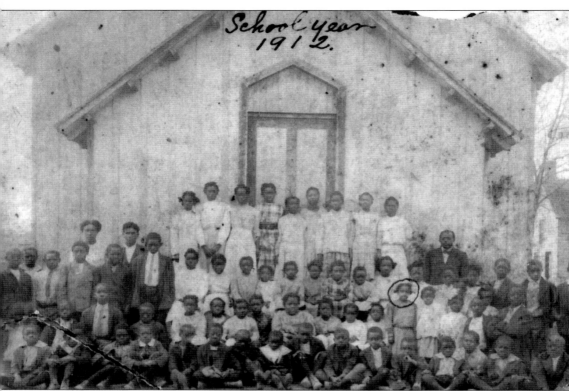

Cross Street School, pictured in 1912, was part of the segregated school system from 1884 to 1932. S.E.W. Camper, a self-educated member of the Cambridge Bar stands on the right. He taught here for more than 30 years and has two daughters pictured, the future Harriet Camper Watkins encircled, and Narcessa Camper Chester standing behind the boys on the left. American Legion Post No. 87 now occupies this site. The earliest organized African-American school in Cambridge was Jenifer Hall of the Waugh Chapel. The school was initiated by Benjamin Jenifer and his wife Hester Anne Jenifer, who bought property near the church in 1837. Nine years after the property was titled to Mrs. Jenifer who was a free woman, Benjamin was emancipated upon the death of Attorney General Josiah Bayly. Bayly, who came to Dorchester County to study law under Congressman Gustavus Scott and earned his room and board tutoring Scott's daughters, went on to educate others, including his slave Benjamin Jenifer. Jenifer in turn passed along his knowledge of reading and writing to others.

This public school, remembered by its students simply as "The Chicken Coop," was on Academy Street near Cedar. At the turn of the 20th century, it housed a "primer" or kindergarten class on the ground floor and a first grade above. Young scholars sang multiplication tables and the alphabet set to tunes, accompanied by a teacher playing and pedaling a small pump organ.

Stanley Institute was moved from Church Creek in the 1860s by the community of Christ Rock. Their descendants, The Friends of Stanley Institute, maintain a museum here today. A one-room school for 100 years, it held as many as 85 students in seven grades. Christ Rock Library, under librarian Bernice Cornish, occupied one corner. The school produced several educators, including William Kiah, who returned to teach here for 15 years.

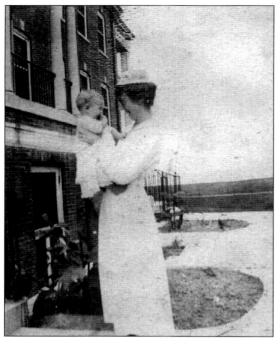

According to one source, early in the history of Cambridge-Maryland Hospital's School of Nursing, "It was nothing in those days for the nursing students to take babies from the nursery to sleep in their dormitory rooms at night."

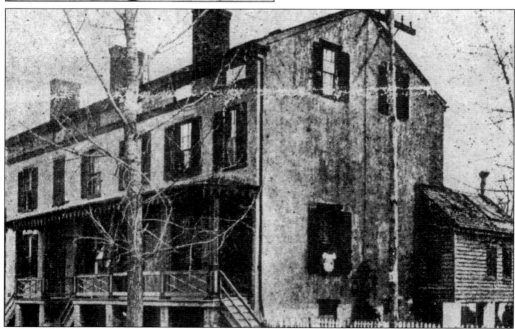

United Charities Hospital on High Street was organized in 1898, Cambridge's first hospital worthy of the term. The first year it treated 288 cases, under the supervision of Dr. Brice W. Goldsborough, chief of staff. United Charities operated six years, housed in two brick structures that were joined together. Surgery was performed in a former kitchen. The Ladies Visiting Committee, forerunner of the auxiliary, assisted hospital efforts to meet the community's medical needs.

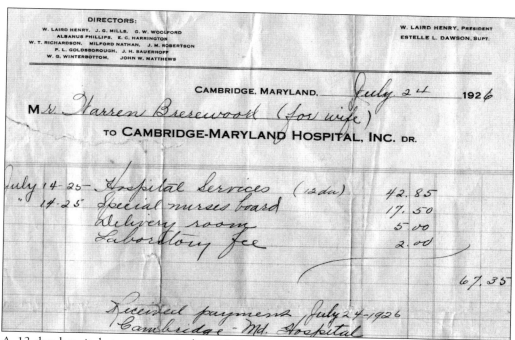

CAMBRIDGE, MARYLAND, _July 24_ 1926

Mr. _Warren Breewood (for wife)_

TO CAMBRIDGE-MARYLAND HOSPITAL, INC. DR.

July 14-25	Hospital Services (12da)	42.85
" 14-25	Special nurses board	17.50
	Delivery room	5.00
	Laboratory fee	2.00
		67.35

Received payment July 24-1926
Cambridge - Md. Hospital

A 12-day hospital stay was typical in 1926 for maternity cases. The board of directors on this bill reads like a Who's Who in Old Cambridge: Henry, Mills, Woolford, Phillips, Harrington, Richardson, Nathan, Robertson, Goldsborough, Winterbottom, Matthews, Dawson, and Sauerhoff.

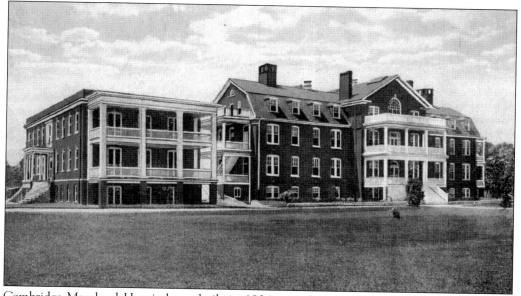

Cambridge-Maryland Hospital was built in 1904 to replace United Charities. John Hurst, a banker in Baltimore, donated $30,000 towards a hospital for his hometown, in what was then rapidly-developing East Cambridge. An addition to the hospital was made possible in 1914 by Alfred I. duPont, who donated funding in memory of his wife, Alicia, for the duPont Maternity Hospital on the left, where women and children were treated.

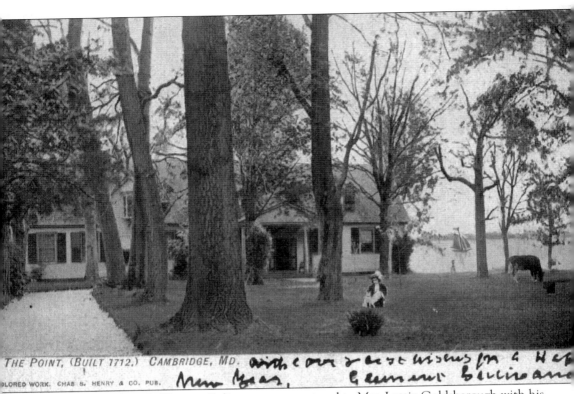

THE POINT, (BUILT 1712.) CAMBRIDGE, MD. *with our & best wishes for a H[appy] New Year, Clement Sulivane*

COLORED WORK. CHAS S. HENRY & CO. PUB.

As 1907 dawned, Col. Clement Sulivane sent a postcard to Mrs. Lottie Goldsborough with his "Best wishes for a Happy New Year." Colonel Sulivane's message says the young lady and cat relaxing under The Point's ancient trees are "Betty Goldsborough sitting on the Point lawn with Billie Bryan." This lawn swept down to the mouth of Cambridge Creek and the lane led from the house to High Street via Commerce Street. Colonel and Mrs. Sulivane moved to The Point from 205 High Street after the death of her father, Dr. W.R. Hayward. An attorney by training, Colonel Sulivane fought with the Confederacy. When Gen. Robert E. Lee's forces retreated from Richmond toward Appomattox in the final days of the Civil War, Colonel Sulivane was the last to withdraw. He commanded the torching of Mayo Bridge to slow the advancing Union Army. Following the war, he returned to Cambridge, where he was associated for the benefit of Cambridge with many of his former adversaries. With E.P. Vinton, he published and wrote for the *Cambridge Chronicle* for 15 years.

Oakley Beach Hotel, Cambridge, Md.

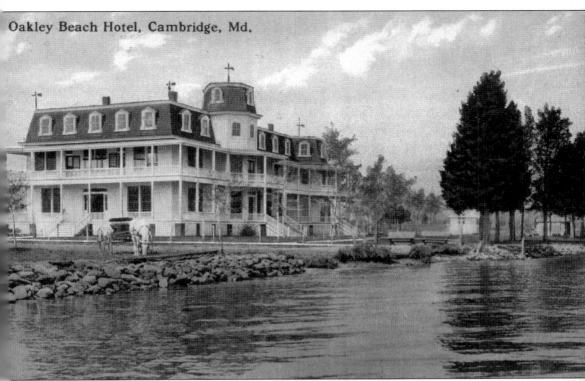

The Oakley Beach Hotel, pictured here on a 1914 postcard, opened at the dawn of the 20th century at the foot of Oakley Street. Standing alone on the Choptank River in a grove of trees, it boasted that a cool breeze always blew "over its spacious porticos and through its large, high-ceilinged rooms, even on the warmest day," no small consideration before air-conditioning. In those days of sail and steamboats sweeping up the Choptank, proprietor U.H. Neal claimed that "every bedroom window affords a charming view of the ever changing marine panorama that is constantly passing." Locals traveled into what was then the suburb to dine in the hotel's cool, lofty public rooms or dance in the pavilion on the river. Visitors from Baltimore and other cities escaped summer's heat by taking up residence for extended periods. The Oakley Beach was destroyed by fire December 6, 1954.

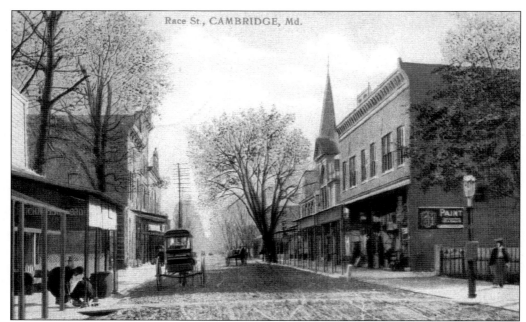

Race St., CAMBRIDGE, Md.

Race Street shortly before 1910 was gas-lit. A 1909 report states, although it was "a little laggard in adopting electric lights, Cambridge will soon be one of the most brilliantly lighted cities on the Eastern Shore," ironic considering the disastrous fire the following year. As in 1892, the fire began in a livery stable, this time ignited by sparks from a nearby merry-go-round engine.

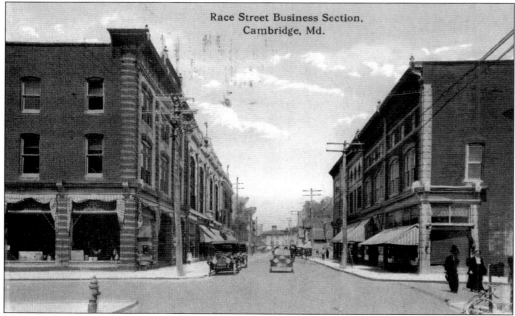

Race Street Business Section, Cambridge, Md.

After the 1910 fire, Race Street was bustling again in this 1930s postcard. The original Phillips Hardware Store lost in the fire had been rebuilt on the opposite side of Race Street, bigger and better than ever. On Saturday, it was impossible to park and difficult to walk the sidewalks as the business district was thronged with local and down-county shoppers.

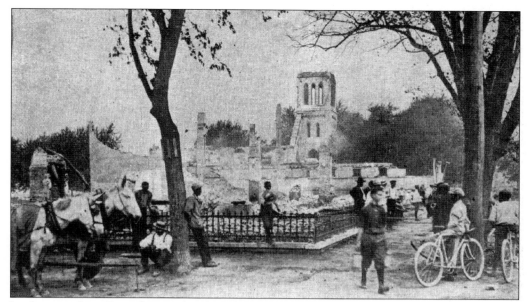

Looking south on Race Street after the July 31, 1910 fire, this postcard shows the ruins of Zion M.E. Church. Eighteen years to the day after the 1892 disaster engulfed older wooden High Street structures, the 1910 fire cost much more in property damages. In addition to Zion Church, the modern home of Cambridge's first Methodist congregation, the second fire destroyed many of the city's more modern brick businesses.

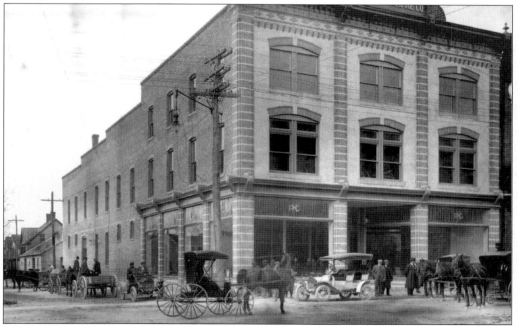

This new Phillips Hardware Company replaced the 1903 original totaled by the 1910 fire. When planning this replacement, a member of the firm assured a local paper that "the building when completed would be the finest on the Eastern Shore and the location decidedly the best in town."

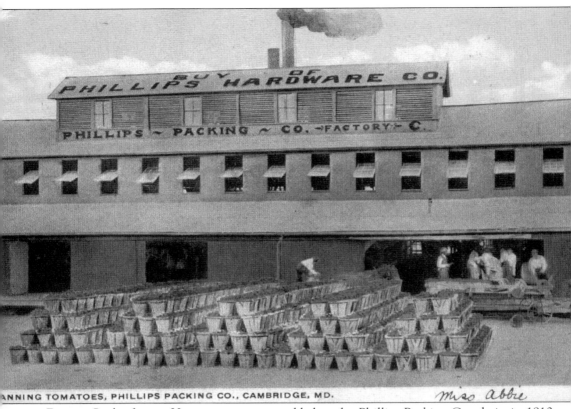

ANNING TOMATOES, PHILLIPS PACKING CO., CAMBRIDGE, MD. *Miss abbie*

Factory C, the former Hearn cannery, was added to the Phillips Packing Co. chain in 1910. Levi and Albanus Phillips and Grason Winterbottom had formed Phillips Packing in 1902 and diversified into canning vegetables, while maintaining separate oyster packing operations. Over the next several decades, they bought up canneries in Cambridge and a dozen other towns in Maryland and Delaware. Cambridge came to be known as the tomato canning capitol of the world, shipping Phillips Delicious brand tomatoes, tomato soup, vegetable soup with tomatoes, tomato sauce, spaghetti in tomato sauce, tomato juice, and other vegetables. Production burgeoned during World War II, when C and K Rations were produced for the military. After being canned by Phillips Packing, wartime rations crossed the bridge to Trappe, where Maurice Adams' Trappe Canning Company had the regional contract to coat canned rations in an olive drab finish that protected the cans from dampness and the consumers from snipers.

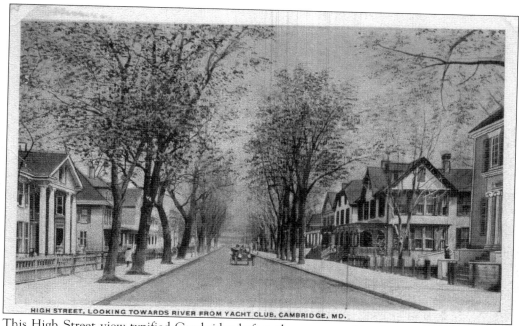

HIGH STREET, LOOKING TOWARDS RIVER FROM YACHT CLUB, CAMBRIDGE, MD.

This High Street view typified Cambridge before the oyster-packing boom of the latter 19th century. A contemporary wrote, "There is hardly a street in the city that has not a water view, and down these streets, with the trees forming a canopy over one's head, there is a lovely vista, with always the dancing waters at the end." Brick-paved High Street retains this charm.

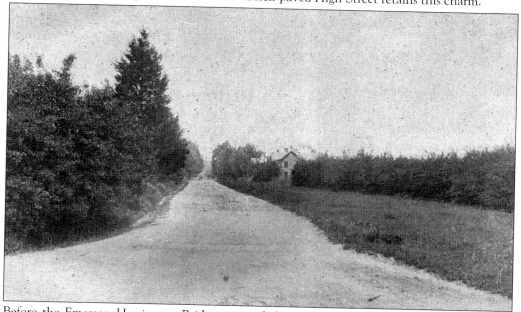

Before the Emerson Harrington Bridge spanned the two-mile width of the Choptank River, there was no land access northward from Cambridge. Maryland Avenue, pictured here in 1896, was one of a number of shell-paved lanes linking the city with the Dorchester countryside. Ground oyster shells created a smooth, hard surface superior to dirt roads common elsewhere. Local promoters remarked on "superb turnpikes" such as this.

Cambridge Yacht Club has been prominent since Alfred I. duPont was its first commodore in 1911. In 1937, Frank duPont sponsored this clubhouse. Invitational regattas attracted excellent sail and powerboats. Spectators followed races from The Bridge, a rooftop model of Commodore duPont's yacht *Alicia*. Rear Admiral Richard Byrd, aviator and polar explorer, lent his name to the club's race series. Gulf's Hall Of Fame inducted eight members as distinguished powerboat racers.

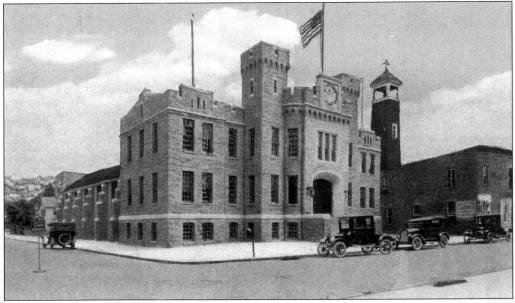

Maryland National Guard's Cambridge Armory was built in 1910, and housed Company C for many years. The armory provided a venue for numerous amusements such as car shows, the National Outdoor Show, skating, and dancing. Company C assembled here after being federalized in 1914, 1916, and World War II. They also celebrated here with subsequent homecoming parades and reunions.

A young Charles I. Prouse is pictured here in 1908, shortly after opening his first tobacco and confectionery store, a "most attractive store located at 37 Poplar Street" according to a newspaper of the time. He later relocated to Race and Cemetery Streets. Mr. Prouse published a series of "pictorial postal cards" when they were a new fad and we are indebted to him for some images in this book.

When Charles Prouse went into business, debate of the new Pure Food and Drug Law alerted the public to possible contamination of sweets. Potential customers were warned, "Nothing is so easily adulterated as candy . . . buy sweets from only the most reliable . . . It would be a good plan to become a regular customer of Charles I. Prouse." Folks did just that and Charlie Prouse and his store became Cambridge institutions.

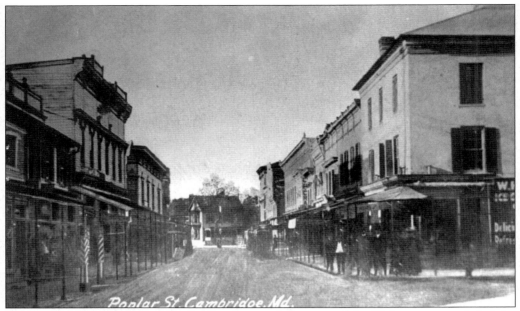

The businesses located along Poplar Street around the turn of the 20th century included the following: E.W. Merrick, Meat, Butter and Eggs; Albert Spedden, the same; Keene and Sherman's White House Lunch Room; Oliver Spedden, Flour, Bran, Tobacco, Seeds and Groceries; D.H. LeCompte, Gents' Furnishings; John A. Tschantre, Jewelry, Watches and Diamonds; M. Warren Hooper, Stationer, Bookseller and Newsdealer; Hurley & Williams, Dress Goods, Ladies' Coats, Furs, and Carpets; Mrs. C.C. McKenzie, Millinery; and Dr. Fessenden Hicks, Dentist.

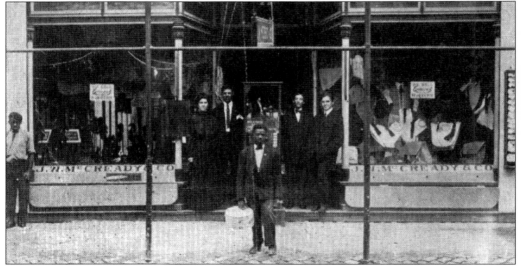

J.W. McCready opened a store at 29 Poplar Street in 1889 selling "shoes, hats, caps and gents' furnishings." Downstairs were shoes for the whole family, including McCready shoes of his design. On the second floor, he carried boots and oilskins, reminders of his childhood on Elliotts Island, where he was raised by his grandfather, oysterman Levin McNamara. McCready's was called "headquarters for . . . goods in Cambridge and throughout this section."

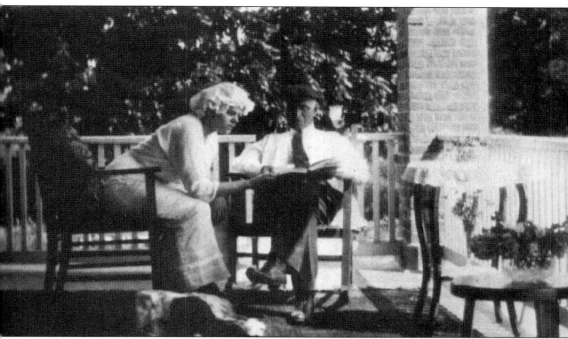

After traveling the world sharp shooting in Buffalo Bill Cody's Wild West Show, Annie Oakley decided to spend her retirement overlooking the Choptank. Born Phoebe Ann Mosey in Ohio, she acquired the name "Little Sure Shot" when Sitting Bull adopted her. Barely five feet tall, Annie was a world-famous phenomenon whose ability strained belief. A favorite of British royalty, in Germany before the Great War she shot a cigarette from the hand of Kaiser Wilhelm. Around 1910 she designed and built a home on Hambrooks Boulevard, where she and her husband rested between tours simply as Frank and Annie Butler. Here they relax early one morning on the porch with their dog Dave, as the sun rises over the Choptank River. Annie played William Tell in her exhibition, shooting an apple off Dave's head. Annie's hair turned from chestnut to white overnight after the show's train wrecked, killing some horses. Ultimately, she and Frank were hired to manage a hotel's shooting range and moved to Pinehurst, North Carolina.

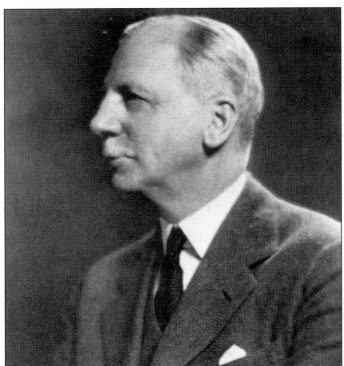

Phillips Lee Goldsborough (1865–1946) was governor of Maryland from 1912 to 1916. Earlier in his career, he was defeated for statewide office by a margin of four votes when he ran for the U.S. Senate in 1896. Subsequently, President T.R. Roosevelt appointed him Collector of Internal Revenue of Baltimore, not the ideal office to endear one to voters. Nonetheless, his second run for statewide office succeeded.

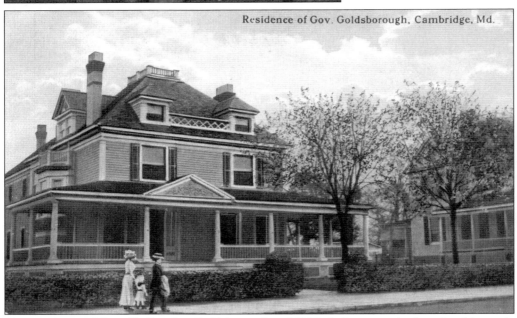

Residence of Gov. Goldsborough, Cambridge, Md.

This residence of Gov. Phillips Lee Goldsborough at 102 High Street was built on land formerly owned by his father. J. Benjamin Brown designed the 1895 house, which is rather simpler than the Queen Anne–style homes he designed on Mill Street. Perhaps this reflects an unpretentious nature in Goldsborough. While on the road, Frank Butler wrote a poem longing for Cambridge, "where we call our Governor Phil."

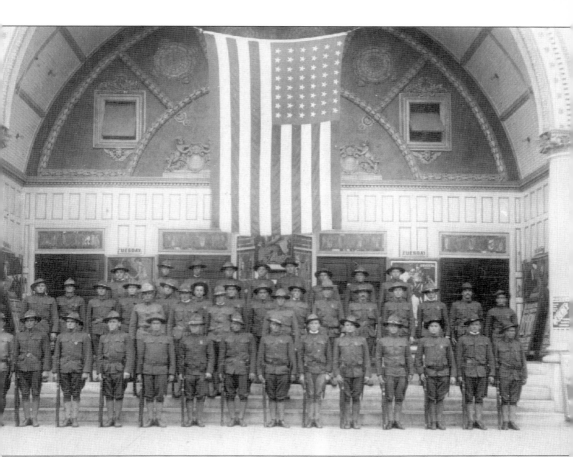

Woodrow Wilson's re-election campaign boasted, "He kept us out of war," but after marching in his Inaugural Parade, Co. C found itself federalized twice during his terms. They are shown at the Grand Opera House after returning to Cambridge from Eagle Pass, Texas, countering raids led by Francisco "Pancho" Villa. The men of Company C are, from left to right, (front row) 2nd Lt. Joseph M. Collins, Sgt. Herman Hughes, Willey, Harry B. Insley, James H. Wartz, unidentified, Fred Brannock, unidentified, Wilbur Newcomb, Levin J. Newcomb, Haston Truman Price, unidentified, William Gorman Willey, unidentified, and Carroll Snow; (second row) Carl Horseman, Holmes Venables, two unidentified, Armond Hayward, Raymond Goslin, six unidentified, Warren C. Paul, unidentified, Brerewood H. Davis, four unidentified; (third row) Sgt. Harold Robinson, Thomas Lantz, Charles E. Mumford, A. Troy Morris, LeRoy B. Edgar Sr, unidentified, Norris, Elmer Hurley, and Cecil Edgar. They posed again in 1917 before embarking for service under Gen. John Pershing's American Expeditionary Force in France during the Great War, from which several never returned.

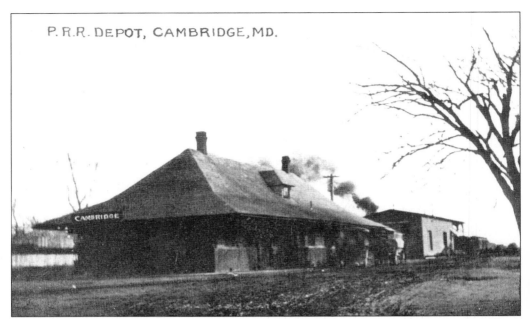

P.R.R. DEPOT, CAMBRIDGE, MD.

Company C received a tumultuous welcome at the Railroad Depot when they returned from Texas in 1916. Thousands met the special train. After the company formed into ranks, a parade followed them to the Armory while the Citizens Band played and families cheered. All who owned automobiles were urged to assemble at the station and join the parade.

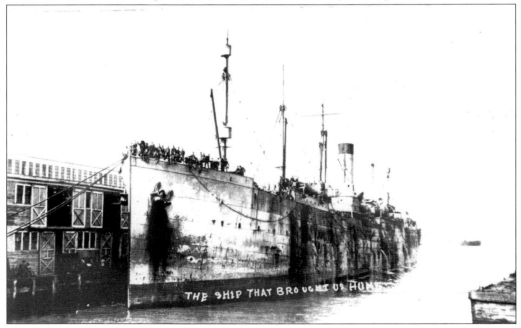

THE SHIP THAT BROUGHT US HOME

A member of Company C inscribed this *Artemis* picture, "The ship that brought us home." Troops anxious to return from France at the close of World War I jammed ports, competing for space on departing ships. The men of Company C felt lucky to embark on this cattle ship until a succession of vessels departing later began to pass them.

Mills, central to settlements from Colonial times, ground grain for daily bread with water- or wind-turned stones. A more modern roller-mill, Green Valley Milling, opened around 1903 at 309 Washington Street, producing 50 barrels of flour and 5,000 pounds of meal daily under names *Best*, *A Family*, and *Liberty Bell*. The patriotic logo was understandable. Owner R.W. Randall had migrated south after many Civil War battles with New York's Light Artillery.

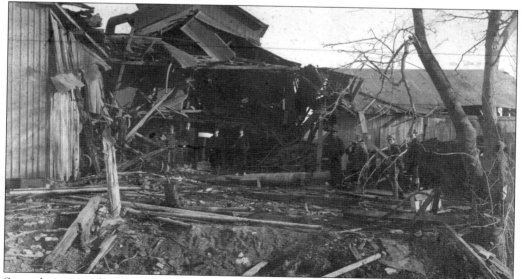

Several men can be seen examining the Green Valley Mill in 1928 after the boiler exploded, killing a mill worker. The fire smoldered for days. This was the last occasion on which Rescue Fire Company's 1910 American LaFrance steam pumper was pressed into service.

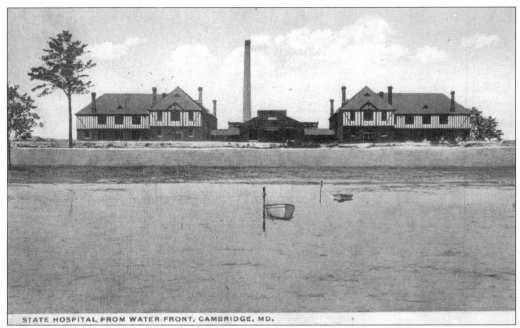

STATE HOSPITAL FROM WATER-FRONT, CAMBRIDGE, MD.

The former Eastern Shore Hospital Center, the Shore's first psychiatric hospital, occupied a 250-acre riverside farm purchased for $25,000 in 1913 from T.H. and W.P. Kirwan. The purchase followed a state report: "The Lunacy Commission, being entirely familiar with the conditions surrounding the insane of Maryland, realize the necessity of relieving the overcrowding of the existing state hospitals." Two early treatment buildings are pictured on this postcard.

The site selected for the Hospital Center was accessible by train and steamboat and had enough farm acreage to be self-sufficient. The first 209 patients arrived May 1915 from the Western Shore by steamboat, following a cruise that included lunch and a dance band. Physical and mental conditions of patients varied widely and the steamer's decks were wound with fencing wire to prevent accidents or suicides and all arrived safely.

The Hon. Emerson Columbus Harrington (1864–1945) was governor of Maryland from 1916 to 1920. Before entering politics, he was an educator and principal of both Cambridge Academy School and the old Cambridge High School in the Muse Mansion. While teaching, he studied law and was elected State's Attorney for Dorchester County in 1899.

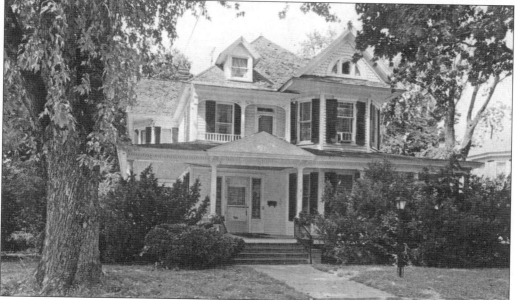

Gov. Emerson C. Harrington was born in Madison and educated at St. John's College in Annapolis. After returning to Cambridge from college, he taught while earning his law degree and in 1897, built this house at 305 Mill Street. The following year the popular educator won his first election.

Lucile, Elizabeth, Hannah, and Virginia, photographed here around 1916 on the Boardwalk in Ocean City, could board an excursion train with their families at Cambridge for a summer outing at the ocean. The Dorchester and Delaware Railroad had reached Cambridge from Seaford, Delaware in 1869, less than five years after the Civil War, igniting business optimism and land values along the way. The editor of one Cambridge newspaper in 1869 advised, "Go to some other village ye men of plodding, antiquated ideas. You but stand in the way of progress here. We want men of nerve, energy, and enterprise. They are coming." He noted, "the business animation the shrill whistle of the locomotive infuses in the masses of people in every county village or town where it is heard." Certainly, this was true of Cambridge, linked by steamboat to the Western Shore and to the cities of the North by rail. When anticipated profits disappointed its founders, the line was absorbed by Pennsylvania Railroad in 1883 and renamed Cambridge and Seaford Railroad.

A Cambridge High School Volleyball Team posed on the school lawn with the old wooden swing-span bridge over Cambridge Creek visible in the background. From left to right are the following: (front row) M. Thompson (net), V. Webb (net and captain), and M. North (center); (back row) E. Slacum (net), H. Mace (center), Miss Nita Parr Perry (coach), Katherine Mowbray (center and manager), M. Dreuning (back), and M. Slacum (back). Substitutes not pictured were Alice Burnhaus, Minta Shuby, Virginia Spedden, and Dorothy Evans. They appear to be such nice young ladies, but their "Sports Yell" must have struck terror in their opponents:

> Bow wow here, bow wow there,
> He bow, she bow,
> Rickety bow wow.
> Team! Team!
> Rah! rah! rah!

Class Song

Composed by Esa Horseman.

Tune: America the Beautiful

I

Oh wonderful the principles taught
To govern our short lives.
Oh worthy all the wisdom sought,
Toward which each true
heart strives.
Oh Cambridge High School, Cambridge
High,
We'll sing our songs to thee.
And may you be throughout
our lives,
Supreme in mem-o-ry.

II

For now we've reached the
closing hour
When seniors say good-bye
But oh! with longing heart
I turn
To thoughts of days gone by
At Cambridge high. Oh Cambridge
High
I sigh for days of yore
And bless the day I found
the way
within thy honored door!

This verse was composed for the graduating class of 1926, Cambridge High School.

Cambridge High School Class of 1926 completed their schooling in the former Muse Mansion, with a class motto of "Deeds Not Words." Commencement exercises were held the evening of June 17, 1926, at the old Arcade Theater, but like many other groups they opted to pose across the street in front of the Grand Opera House. This elaborate facade was removed from the Opera House in 1948 when the building was remodeled into Philip Frankel's clothing store. Mr. Frankel's daughter Bea, a 1943 graduate of Cambridge High School, later gained fame as TV actress Bea Arthur, featured in "All in the Family" and star of "Maude." The Grand Opera House was remodeled again in 1998 from Curtis-Mathis into Craig's Drug Store. Craig's has served Cambridge since 1867 from various locations.

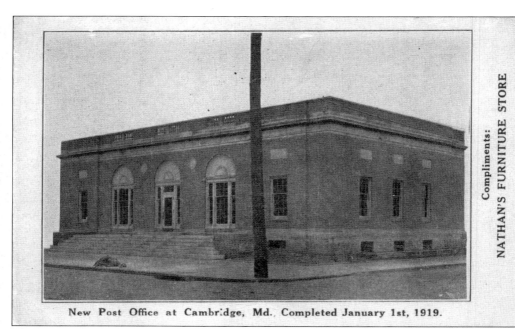

New Post Office at Cambridge, Md., Completed January 1st, 1919.

This postcard was part of a series sponsored by Nathan's Furniture. Since Nathan's first store was destroyed by fire originating behind this site, they were undoubtedly pleased with their new brick neighbor. To make room for the post office, it was necessary to raze Charles E. Finley's studio, where many turn-of-the-20th-century photographs originated.

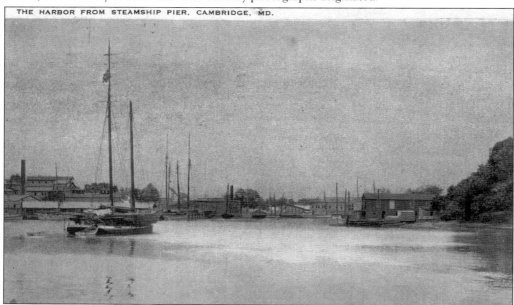

THE HARBOR FROM STEAMSHIP PIER, CAMBRIDGE, MD.

This postcard shows the approach to Cambridge Creek harbor from the broad Choptank River. The Choptank River is 68 miles in length, the Eastern Shore's longest. This view postmarked 1924 looked in across The Point from the steamboat wharf of B, C and A Line at the foot of High Street. Before the steamboat wharf and terminal building, the foot of High Street was a grassy common enjoyed by all of Cambridge.

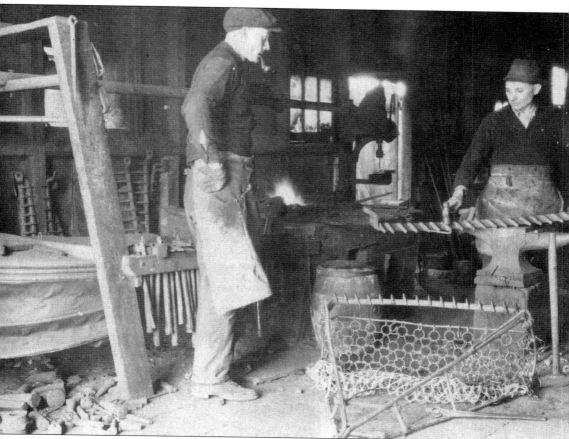

Joseph Brocato Sr. emigrated from Sicily in 1889 and soon landed in Cambridge. He blacksmithed on Market Street, at the west end of Cambridge Creek bridge, and is shown (right) at the anvil in the early 1930s working on an oyster dredge. Behind William Shenton on the left is the bellows, which pumped air into the forge until the coals hummed with white heat. Joseph Jr. went to work in the shop as a boy pumping the bellows and carried on the Market Street shop from his father's death in 1950 until urban renewal forced him out in 1968, long before there was a comprehensive plan for the area. Joseph Jr. had the last surviving business on Market Street. He lost his battle with City Hall and relocated to Sunburst Highway, where he continued serving the dwindling oyster fleet. During the off-season, he exercised his artistic side forging decorative ironwork, some of which can be seen on the grounds of the Brannock Maritime Museum.

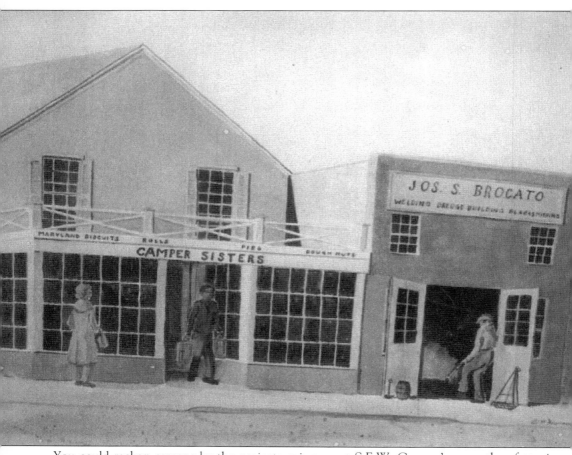

You could reckon seasons by the projects going on at S.E.W. Camper's: were they fattening chickens, ducks, and guineas, or dressing fowl and making crowsfeet wreaths? In 1919, his six daughters—Harriet, Maye, Narcessa, Carey, Alice, and Rebecca—opened for business on Market Street, catering to oystermen. Harriet's son, Commissioner Edward Watkins, was among offspring and relatives pressed into service. Originally, the sisters served meals, but over time became famous for baked goods. Eastern Shore beaten biscuits were worked between hammer and block until Edward Watkins returned from World War II and perfected a machine to replicate those pummeled by hand. Then the sisters could crank out 200 dozen a day. Their pies were legendary: apple, cherry, blueberry, chocolate meringue, and last but not least, sweet potato. When Whitey Barth asked for an exclusive on their pies for Candyland, the sisters decided to wholesale and delivered all around the area. Urban Renewal struck in 1965 but Camper Sisters Bakery lives in memory. Shirley Brannock painted this image of the bakery and its neighbor.

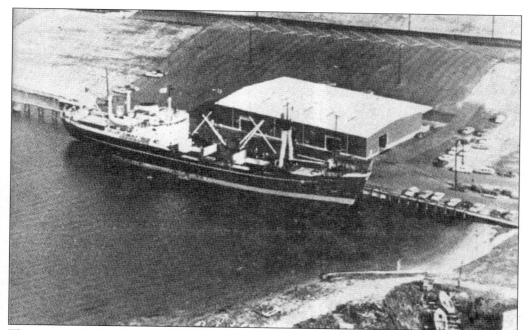

The port of Cambridge has a history that dates back to Colonial times, when it was authorized by the Maryland Assembly as an official port of entry for trade between Lord Baltimore's province and the world. Nearly 300 years later, Cambridge Marine Terminal was completed just above Cambridge Creek, making it the only deep-water port on the Eastern Shore. The terminal now serves as an entertainment venue at Sailwinds Park.

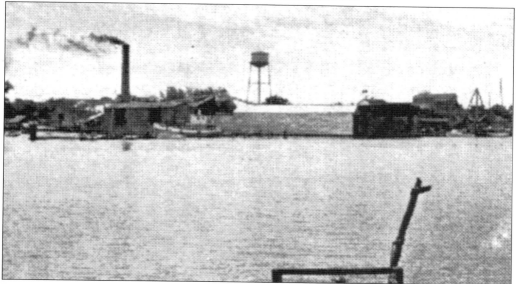

Many noted shipbuilders worked around Cambridge Creek's shore. Various members of the Davis family of Dorchester County, who later gained international fame on Solomons Island building racing yachts, operated out of East Cambridge for decades. At least three sizable whalers were built in the creek for New England masters. During World War II, the production record of the Cambridge Shipyard pictured here was used as a model by the military.

Nurse Betty Meyer tends to a young patient in this photo taken around 1925 at Cambridge-Maryland Hospital. On the porches overlooking the Choptank River, patients could view the river traffic and enjoy fresh air while absorbing beneficial rays of the sun. Before air-conditioning, the breezes off the river alone must have been curative.

Myra Deane, then-assistant superintendent of nurses, is on the right in this photo from the mid-1920s. Before a separate building was created for nurses, they roomed on the hospital's top floor in halls on either side of a centralized sky-parlor and classrooms. The end of the hall including Superintendent Deane's room was known to the students as "society row." At the opposite end, girls called their hallway "pigs alley."

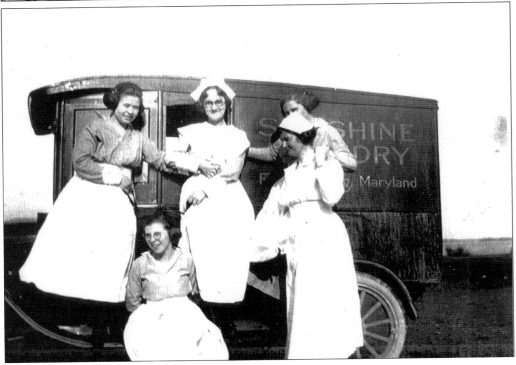

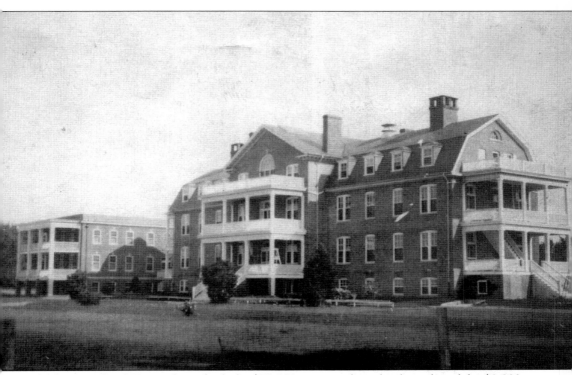

Cambridge-Maryland Hospital was built for $70,000 on waterfront land purchased for $3,800 from Mr. and Mrs. William Fletcher. J. Benjamin Brown constructed it according to a design by George Archer of Baltimore. It was dedicated November 17, 1904, a day of rejoicing when schools closed and court adjourned. A nursing school program was offered soon afterward. The separate building shown in the background was used for nursing classes and a dormitory was added in the early 1930s with the generosity of Zoah Brinsfield. In 1958, the Diagnostic Treatment wing and former third floor operating rooms of the hospital were combined and dedicated. Dr. Brice Goldsborough was instrumental in establishing the United Charities Hospital in the 1890s and again in establishing Cambridge-Maryland Hospital, both of which he served as chief of staff. When Dr. Goldsborough died in 1929, an editorial in the *Baltimore Sun* said he was "born to like and be liked . . . a real brother over and under the skin to all humans." An auxiliary has been active from the days of the United Charities Hospital to today.

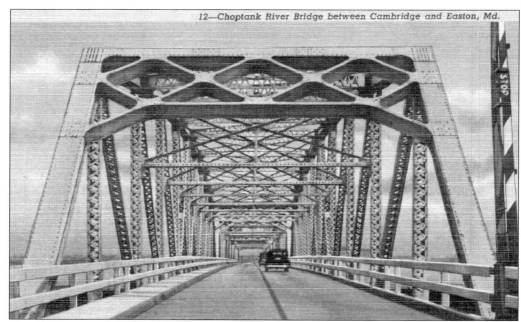

Cambridge's first direct link northward was the Emerson C. Harrington Bridge, completed in 1935. Franklin D. Roosevelt arrived aboard the presidential yacht and dedicated the bridge, financed by the Public Works Administration he instigated to provide employment during the Depression. The swing-span that pivoted to allow larger ships to pass through was removed on completion of the taller Malkus Bridge. This bridge is now a fishing pier.

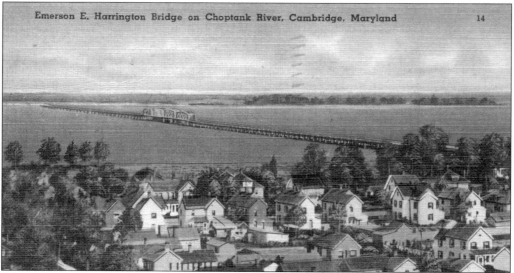

Emerson E. Harrington Bridge on Choptank River, Cambridge, Maryland 14

Construction of the Harrington Bridge between 1933 and 1935 provided residents a marvelous spectacle, climaxed by its dedication. The president and governors of neighboring states attended, amid parading cars and boats, feasting, and fireworks. The completed span was an engineering feat and a big attraction. Until Chesapeake Bay was spanned, it was Maryland's longest bridge, carrying Sunburst Highway across two miles of Choptank River. It became economically vital following the demise of steamboats.

Capt. Charles B. and Lizzie Frances Todd are shown stepping out in the 1940s from the Academy Street home where they raised eight daughters and two sons. Captain Todd dredged a two-masted bateau, the *William H. Todd*, named in honor of his father, a native of Crocheron, who built the boat for him.

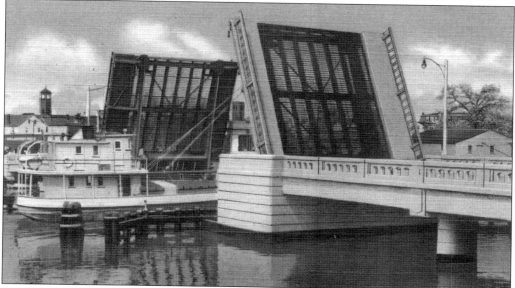

In 1940, this drawbridge over Cambridge Creek replaced an earlier wooden span dating back to the 1890s. Between those dates, East Cambridge developed as a residential area and industry burgeoned along the railroad track and creekside. Most familiar passing through the draw were the six diesel-powered buyboat-type vessels of Phillips Packing Company: *Amos, Andy, Popeye, Wimpy, Mutt,* and *Jeff,* named after comics in an uncharacteristically playful moment.

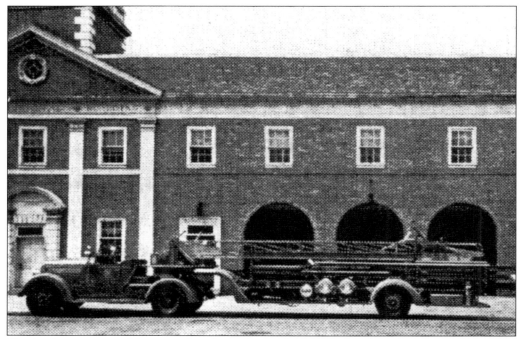

Cambridge is protected from another disastrous fire by Rescue Fire Company, which succeeded the 1843 United Fire Company in 1882. By 1909, the company boasted a Silsby engine, two hose carts with 2,000 feet of hose, and a hook-and-ladder truck. For many years, their pride and joy was this hook-and-ladder dubbed the *Queen Mary*, pictured here around 1949. The *Queen Mary* was purchased in 1937 for $18,000 and cost $65,000 to replace.

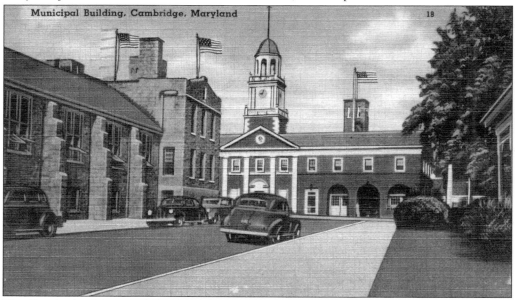

The Cambridge Municipal Building, pictured here in a 1946 postcard, was completed at 307 Gay Street in 1926, consolidating the city's administrative offices with Rescue Fire Company. It currently houses City Hall, Rescue Fire Company, and Cambridge Emergency Medical Service.

Four
POST-WAR CAMBRIDGE

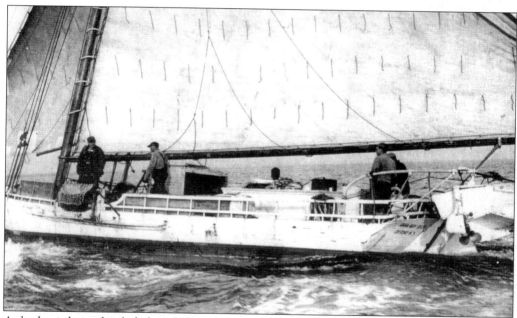

A dredge is being hauled aboard the skipjack *Anna Mae Rich*, which worked out of Cambridge Creek in the 1950s and 1960s under Capt. Charles W. Todd. At that time, dredge boats still anchored out during the week and returned only on weekends, often rafting up at the wharf eight or more across in the crowded harbor. By staying out on the wintry river on weeknights, the captain was in sight of the oyster beds when sunrise made it legal to dredge, plus he need worry about his crew's whereabouts only once weekly. Buyboats, often schooners converted to power, took the catch off daily and shuttled it to packinghouses. The captain, the dredge boat, and each crewmember got a share, after the "grub bill" was deducted from income at week's end. In modern times, to the great relief of crews, dredges are hauled alongside by a donkey engine. Formerly, the weighty apparatus and its contents were wound in and hauled aboard by hand.

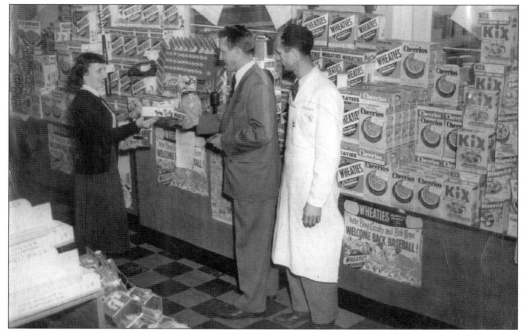

Pictured with General Mills's representatives, Jimmy Simmons (right) displays a hint of the marketing genius that made him a Cambridge institution. He and wife Elizabeth introduced self-service shopping to the Eastern Shore, even though it meant that they would have to push shopping carts for crustier male customers, who persisted in dragging them rather than pushing. When shown the proper technique, still they balked at anything akin to pushing a baby carriage.

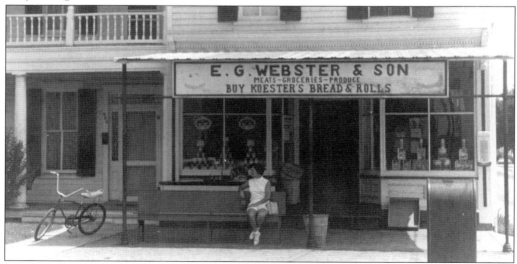

E.G. Webster and Son opened at 810 Race Street in 1939 for $750, lock, stock, and barrel. His grandchildren, Roger Webster and Elaine Horseman, still serve the neighborhood from the nostalgia-filled store outfitted with original fixtures. Along with traditional meats, oysters, and muskrats, Roger sells a hardbound pictorial history he co-wrote, *Cambridge: Past and Present*. In July 1967, their aunt, Peggy Brohawn Ellis, relaxed in the shade of the awning.

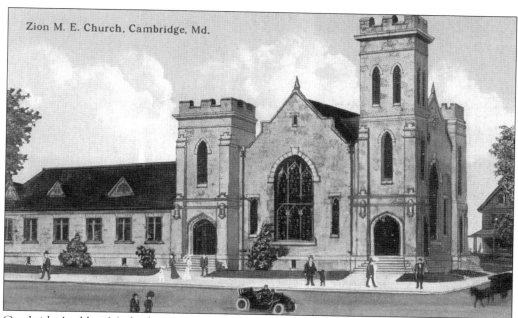

Zion M. E. Church, Cambridge, Md.

Cambridge's oldest Methodist congregation, Zion Methodist Church is the second on this site. This church was built in 1911 and rebuilt after it was gutted by fire in 1950. The church's fellowship hall is dedicated to Rev. Freeborn Garrettson in honor of his bringing Methodism to Dorchester County. From 1802 to 1846, Zion Church and graveyard were located at Church and Mill Streets. The church moved to Race Street and the graveyard to Cambridge Cemetery.

This photo shows a crowd gathered in front of the former Dorchester County Library at 305 Gay Street, now the city council chambers. This library was built in 1939 at a cost of $20,000 and replaced in 1973. A library for the African-American community was founded on Pine Street by the Mes Amies Literary and Social Club. The Wallace Mansion stands on The Hill in the background, site of the current library.

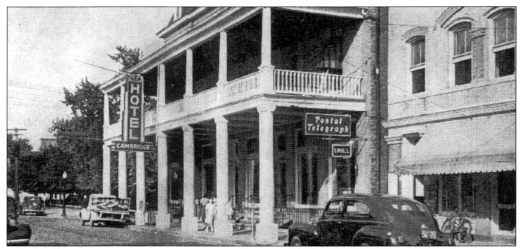

This view of the Hotel Cambridge from around 1940 shows a two-story porch later replaced by an awning. The 1892 fire had killed all the trees that once shaded this block of High Street. Proprietors Mr. and Mrs. Benjamin Frisch advertised "44 Rooms Opposite the Post Office and Courthouse. Only a short distance from the famous Choptank River Bridge."

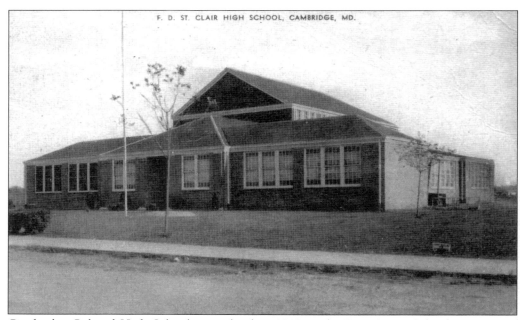

Cambridge Colored High School, accredited in 1918 in the Pine Street School, was one of Maryland's first public "colored" high schools. Frederick Douglass St. Clair High School, pictured here on Fairmount Avenue, opened in 1932, a social center as well as the county's only black high school for 20 years. After it burned in 1952, classes continued at the Elks, Waugh, and Bethel Churches until completion of Mace's Lane High School, which integrated into Cambridge High School in 1969.

In the late 1950s, the Cambridge Junior High School Glee Club practices in the gym for their annual Christmas Candle Light concert under the direction of Ms. Lottie Webster. In the 1950s, seventh- and eighth-grade classes were taught on Glasgow Street in the building now housing the Board of Education.

Cambridge High School moved from the Muse Mansion in 1930 to School Street between Talbot and Somerset Avenues. On September 6, 1935, fire forced the school to return to the Muse Mansion for a time. Students kept busy reading the *Hottentot*, the school newspaper, where they could follow the exploits of their Raiders teams. Under Coach James Busick, the girls basketball team won 68 consecutive games and claimed three state championships for Cambridge.

Elsie McNamara worked at *The Daily Banner* for 56 years as an award-winning reporter, managing editor, and columnist. Her "Rocking Chair" column ran 45 years. An early preservationist, her campaigns blocked paving over High Street's bricks with asphalt and established funding to fence and care for Cambridge Cemetery. Miss Elsie was beloved by the public and courted by politicians, including John F. Kennedy, who paused while campaigning and tried this rocker.

Many Cambridge newspapers have come and gone; most of them voice of a particular political viewpoint. The *Democrat and News* was suppressed by the government at the opening of the Civil War and reappeared afterwards as the *Cambridge Herald*, later the *Democrat and Herald*. Longtime employees of *The Daily Banner*, the Shore's oldest daily, included (from left to right) Maurice Rimpo, editor; Elsie McNamara, managing editor; Herman Stevens, publisher; and Mina Rossy, bookkeeper.

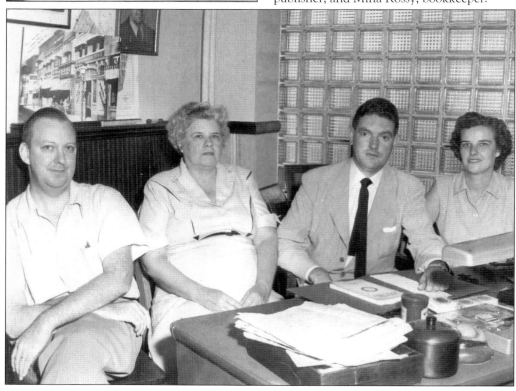

Merritt Foxwell of J.M. Clayton Co. lifts a stainless-steel crate of crabs from the steamer to cool enough for picking. Depending on their size, crabs are either "picking" or "basket" crabs. A crate of 400 pounds of live crabs yields 40 pounds of meat. Today, this business run by the Clayton Brooks family is the sole surviving seafood operation on Cambridge Creek.

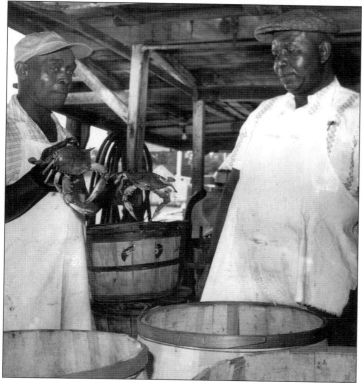

Greenbury Ennals (left) and Webb Dorsey display jumbo crabs on the landing dock at J.M. Clayton Co. in 1960. The Dorseys were one of the families who moved to Cambridge with John M. Clayton when he relocated his seafood operation from Hoopers Island in 1921. Being cyclical creatures, such large crabs disappeared from the Choptank for a number of years but returned in significant numbers in the 2001 season.

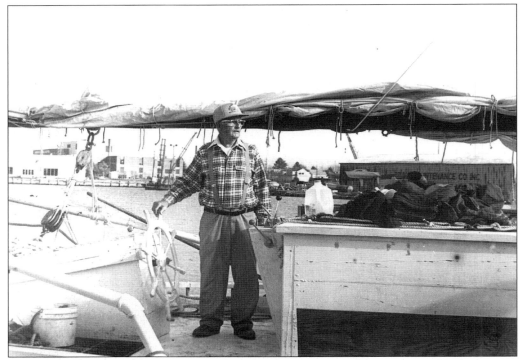

Capt. Charles W. Todd stands at the wheel of the skipjack *Helen Virginia*, owned by his son-in-law and daughter, Ernie and Christine Barlow. Over Captain Todd's right shoulder is the County Office Building, once site of Ivy Leonard's oyster and tomato houses, where he formerly tied up and sold oysters to Tom Leonard. Yacht Maintenance to his left occupies a portion of property where Cambridge Manufacturing was located.

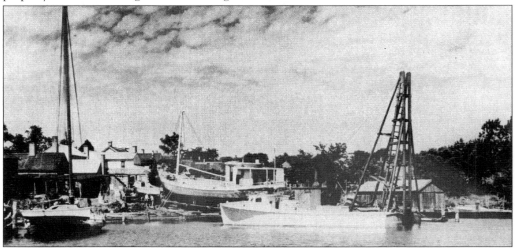

The marine railway, pictured here by the tall pile driver in 1954, was at the foot of Muir Street. The railway was one of several located on Cambridge Creek. William Davis and William Hopkins established a railway in 1868; George T. Johnson and Sons were Bridge, Ship, and Wharf Builders in 1890. J.W. Crowell's shipyard, later Cambridge Manufacturing, included a marine railway on a ten-acre site where Yacht Maintenance is now located.

Five
THOSE WHO SERVE

The Lyte family pictured here are examples of Dorchester Countians living the old Goldsborough family motto, *Non Sibi*, Not For Self. Pictured from left to right are Tina Lyte Meekins, Gwendolyn Lyte, and Rev. Ernest Adam Lyte. Ernest Lyte returned to Cambridge from the Army following World War I to enter the ministry, pastoring for 40 years in seven churches in the Baltimore AME Conference. He and Mrs. Lyte, wed in 1934, operated Elyte Cleaners for 30 years, with shops on Pine Street and in Easton. Mrs. Lyte held volunteer church and civic positions and worked with Dorchester County Development Corporation, assisting seniors with finding employment until retiring at 85. Reverend Lyte was appointed by Gov. Marvin Mandel to the Human Relations Commission of Maryland and reappointed to serve under Gov. Blair Lee. In the family tradition, Tina Lyte Meekins helps others as an educator, teaching in the Dorchester County Public School system and at Salisbury University's Maryland Summer Center for the Performing Arts.

Effa Murphy Horseman relaxes after a shift at Cambridge-Maryland Hospital, where she earned her cap and pin in 1918. She lived at the hospital and served throughout the Influenza epidemic that killed over a half-million Americans in one year, working seven-day, twelve-hour shifts. She retired to private duty nursing in her 50s and lived to 102, enjoying her multitude of friends and women's right to vote.

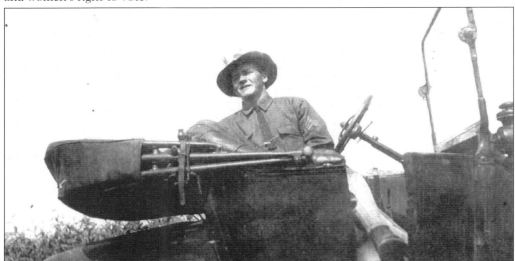

Sgt. Carl Horseman served with Company C, Maryland National Guard. In 1918, he earned the Distinguished Service Cross in France "for extraordinary heroism in action . . . voluntarily left shelter and went thru heavy fire to rescue men wounded when a shell struck their dugout. After administering first-aid treatment, he assisted them to a dressing station." After the war, he was Drum Major for Cambridge American Legion's champion Drum and Bugle Corp.

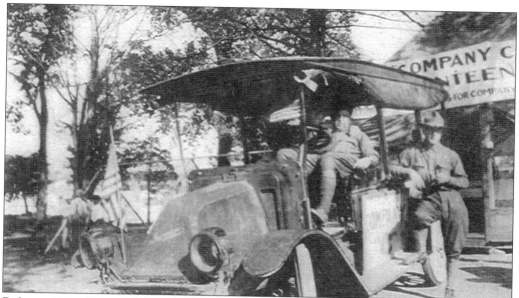

Before going to France in World War I, Co. C of the Maryland National Guard was federalized in 1916 and dispatched across the country by rail from the Cambridge depot to Eagle Pass, Texas. There they defended the border from raids across the Rio Grande River being led by Francisco "Pancho" Villa.

The Cambridge Police Department was another group that posed before the Grand Opera House on Race Street. Pictured on the Opera House steps are all the officers on the force in 1914. From left to right are Charles Shorter, Ed McBride, Chief Charles Pritchett, Daniel Brannock, and George Moore.

The Salvation Army ministered in Cambridge in the 1880s, opening a shelter on Race Street. Supplemented by local charities, the Salvation Army assisted oystermen. Periodically, protracted freeze-ups locked dredge boats in the harbor, stranding many crewmen without work, far from friends or family. Commonly referred to as "tramps" or "Paddies," many were non-English speaking or otherwise alien to the local populace.

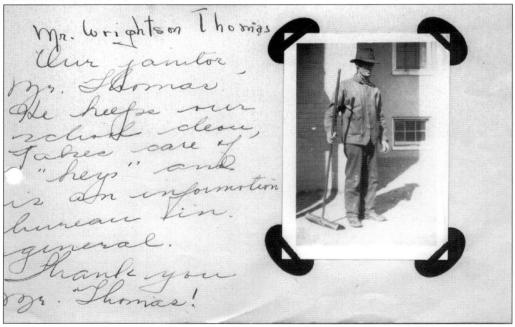

Along with the usual memorabilia of a graduating student, this tribute to Wrightson Thomas was found in a souvenir scrapbook for the Cambridge High School, Class of 1926: "Our janitor Mr. Thomas. He keeps our school clean, takes care of 'keys' and is an information bureau in general. Thank you, Mr. Thomas!"

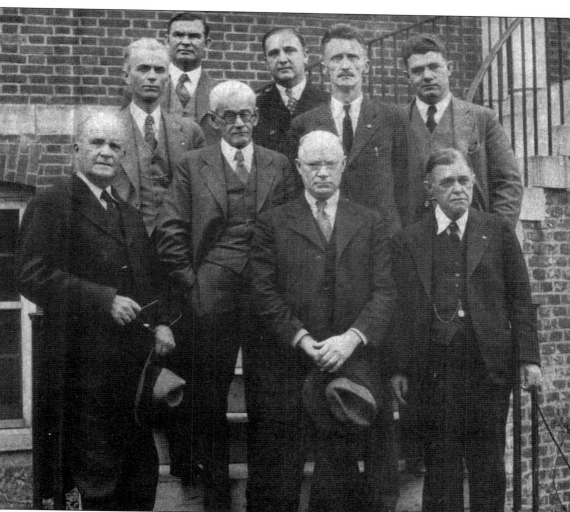

The 1930 staff pose outside of Cambridge-Maryland Hospital. From left to right are the following: (front row) Dr. Guy H. Steele, Dr. E.A. Jones, Dr. Joseph K. Shriver, and Dr. Eldridge E. Wolff; (back row) Dr. P.P. Payne, Dr. P.H. Tawes, Dr. Gilbert H. Meekins, Dr. Wilton E. Dingus, and Dr. John Mace Jr. Dorchester County doctors were noted for their devotion to duty and willingness to travel where needed despite the difficulties. What was said of Dr. John Mace Jr. could be applied to each of his colleagues, "All his life he took an active interest in his community, being an 'old country doctor' loved by all." In its early years, the Cambridge-Maryland Hospital had three father-son medical teams: Dr. Eldridge E. Wolff and his son Dr. Eldridge H. Wolff; Dr. Thomas Steele and his son Dr. Guy Steele; and Dr. John Mace Sr. and his son Dr. John Mace Jr.

James Lynn Stubbs heard news of Pearl Harbor on December 7, 1941, at his father's house in Charlotte, North Carolina. Six months away from high school graduation, he feared the war would not last until he could get there. Upon graduating, he enlisted in the Navy and served through the thick of many battles with the medics, attaining a first Class Pharmacy rating. He has since preserved a large archive on regional military history.

WT3 Charles W. Todd left a draft-deferred state job to join the Navy during World War II. While in the Pacific with the CBs building airfields, he offered what comfort he could to wounded Marines evacuated to Guam from amphibious assaults. In the Marianas, he once had a chance to treat his unit to a taste of home with a liberated case of Phillips Pork and Beans.

Montro Askins, pictured at Moton Field at Tuskegee Institute in Alabama, trained with the Tuskegee Airmen, an Army Air Corp unit of African Americans who distinguished themselves in World War II. Their record on 500 wartime missions influenced desegregation of the Armed Forces. Interested in mechanics, after the war, Montro Askins settled on Pine Street and worked as a long-distance truck driver. He was a quiet man who kept his accomplishments to himself.

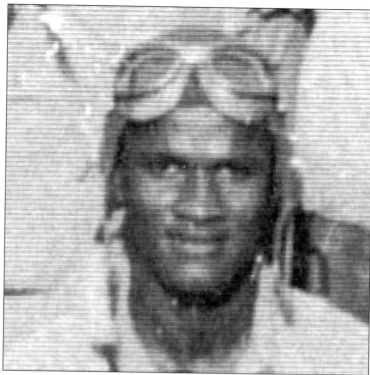

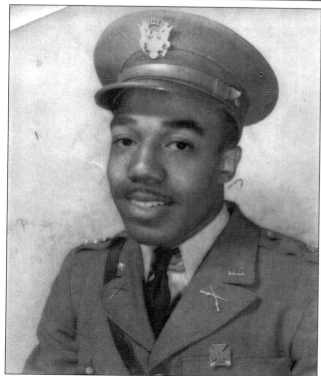

After earning his degree from Howard University in Washington, D.C., Edward Watkins entered the Army early in World War II. He was commissioned as a second lieutenant specializing in communications and served in the wake of the Allied advance across Europe from England through Belgium, France, and Germany. When he returned home, he served the community as a social worker and as a Cambridge City Commissioner for the past 35 years.

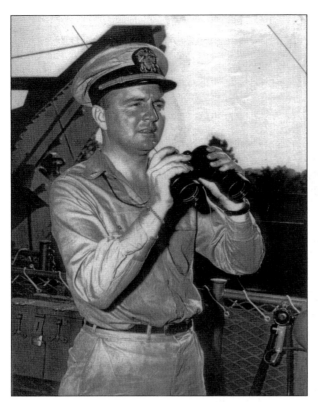

James G. Busick Sr. taught and coached before World War II. He enlisted in the Navy and by war's end, he was a lieutenant commander, decorated by Admiral Spruance for "leadership and cool efficiency in the performance of his duties and his courage while under enemy fire." His coolness served him well in the 1950s and 1960s as Superintendent of Schools, guiding the system through consolidation of community schools and desegregation.

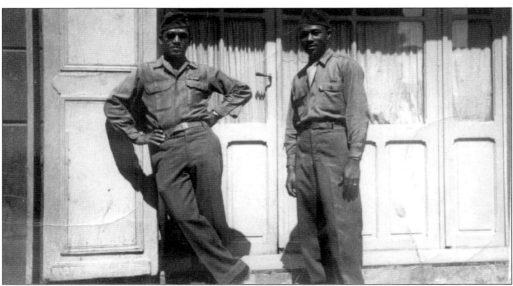

Emerson Lincoln Stafford (right) relaxes here on leave with a comrade while serving in Europe. He served throughout World War II, from 1942 to 1945, seeing action in both the European and Pacific Theaters, from North Africa, Italy, and France to the Philippines. For part of his overseas tour, he served with another Cambridge graduate Harvey Chase, who later became the Reverend Chase of St. Lukes UM Church.

Milford Nathan was active in community affairs as well as the furniture business his father established. Upon his death in 1953, his Will established the Nathan Foundation, to benefit Dorchester County causes. His widow, Estelle Nathan, left the bulk of their estate to the foundation in 1960. His sister, Bertha Nathan, had moved to New York but had not forgotten her hometown. She admired the foundation's work and left it much of her estate in 1983.

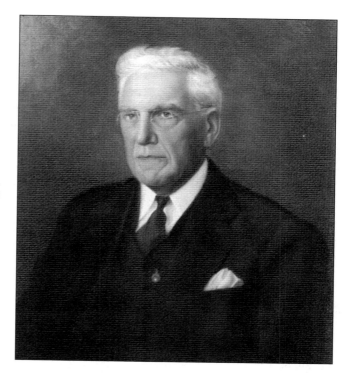

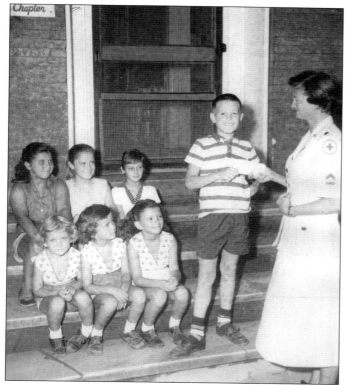

The Red Cross has operated in Dorchester County since 1917, having opened a chapter during World War I. In this late 1940s photo, children donate from their efforts by presenting a check to Dorothy Slacum, director of the Dorchester County Red Cross for 30 years. Before there was a local pool, the Red Cross sponsored swimming lessons for youngsters in a roped-off area on the Choptank River at The Pines.

Sarah Askins Stafford, oldest of 11 children, held her family together, raising younger brothers and sisters after their parents died. She later served as a midwife to blacks and whites in Cambridge and outlying areas while raising three children of her own. After reaching age 51, she earned her GED and LPN diplomas and sampled college in Chestertown and New York. She is shown here in 1944 with her youngest child Enez Lincolna Stafford.

The "doctor" (left) and "patient" may be posing, as shoes sticking out on the operating table suggest they were only testing new X-ray equipment. The other people pictured in this 1960s photo are the real medical professionals, having aided Cambridge patients for many years. Included in the photo are, from left to right, unidentified; James Carpenter, x-ray technician; Virginia Skinner, registered nurse; and Nelson Cornish, orderly. Ms. Skinner retired from nursing at 70 to volunteer at the Ladies' Auxiliary Robin Hood Shop.

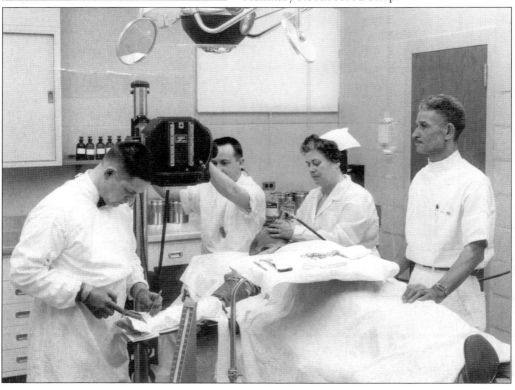

Officer Daniel Bier (1924–1953) lost his life when he was shot responding to a domestic dispute call at a local residence. A native of Philadelphia, he served the Cambridge Police Department for six years. Respected by young and old alike, Officer Bier is the only officer of the department to have lost his life in the line of duty. He epitomized the department's motto: With pride we serve.

These men and women serving Cambridge in 1956 took time to be photographed at their headquarters in the Municipal Building. From left to right are the following: (seated) Karl Schwarck, John Vickers, Crossing Guard Mary Rawleigh, Frances Twilley, Randall Dayton, and Joe Larrimore; (standing) Chief Brice Kinnamon, Clerk Harry Reed, John Bramble, Bradford Vickers, Charles Bramble, Randolph Jews, Samuel Wilkins, Russell Gray, Theron Newman, Otto Cheesman, John McGloughlin, Clerk Vivian Ewell, and Assistant Chief James Leonard.

S. Sgt. Robin H. Askins of the 82nd Airborne saw service during the Vietnam War and in Korea before losing his life in 1970 while stationed at Fort Bragg, North Carolina. His sister, Rev. Enez Stafford Grubb, also served as a sergeant in the Army Reserve. She is currently the pastor of Mount Olive AME Church in Salisbury, and acting director of Sojourner Douglass College's Cambridge Center.

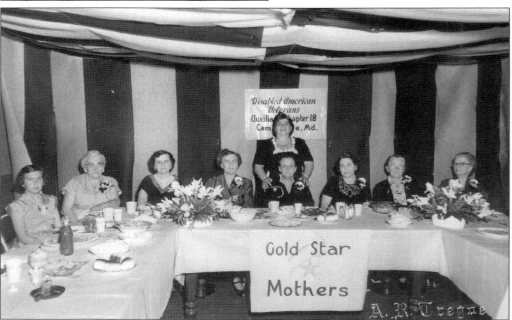

The Gold Star Mothers of Cambridge are being honored here by Disabled American Veterans Auxiliary Chapter 18 at American Legion Post #91. The Gold Star Mothers were those who lost a child in service of their country.

Six

JUST FOR THE FUN OF IT

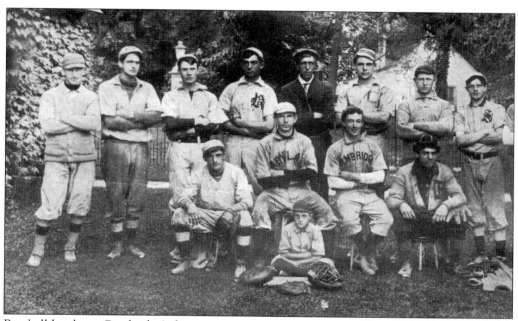

Baseball has been Cambridge's favorite spectator sport since it supplanted the horse races that gave Race Street its name, although bicycle and boat racing have had their moments. Teams such as this 1908 group were not professionals, but occasionally fans showed their appreciation in a material way. The story is told of a good local player who came up to bat in the eighth inning and, with two outs and two strikes against him, hit a home run over the left field fence. Pandemonium stopped play and a fan borrowed a hat and went through the bleachers and grandstand urging in a singsong voice, "Let's fill the hat up for him. He's a hero today. He may be a son of a . . . tomorrow." Perhaps it should be noted that baseball games were stag affairs at one time, thought inappropriate for the gentler sex. Regardless, the batter needed a paper bag to carry off the collection.

The Literary Study Group in 1898 met in the homes of members. In 1900, they initiated efforts to establish a public library in Cambridge. In 1901, their name was changed to the Woman's Club of Cambridge. The club ladies sponsored recitals and musicals to raise funds and opened a Reading Room at High and Poplar Streets.

In 1922, the Public Library was established with the help of former State Librarian Nettie V. Mace. The library was housed in Sycamore Cottage, the newly acquired clubhouse of the Cambridge Woman's Club, who donated their collection of 1,000 books, the core of Dorchester County Public Library. Separate collections were established by group efforts on Pine Street and at Stanley Institute. In 1939, the Public Library moved to this building, which now houses the city council chambers.

THE S.S. BAY BELLE

★ Baltimore's *latest all-steel streamlined* excursion cruiser, completed in 1941, accommodates 2400 passengers and offers such features as a spacious dance deck, observation decks, refreshment service, and the ultimate in passenger comfort.

ANNOUNCING

CAMBRIDGE, MARYLAND CRUISES

SEPTEMBER 18, 19, 20, 21 & 22

LEAVE PIER 8 LIGHT ST. 9 A. M.
LEAVE CAMBRIDGE, MD. 5 P. M.

FARE: $1.50 WEEKDAYS
2.00 SUNDAYS

WILSON LINE, INC.

POST CARD

The *Bay Belle* was a popular steamboat in the 1940s. It came from Wilmington, Delaware, in the spring, docking at Long Wharf to offer excursions. The Wilson Line also ran excursions out of Baltimore and Washington, D.C., to Norfolk and George Washington's home at Mount Vernon in Virginia, and to amusement parks at Marshall Hall and Tolchester Beach in Maryland.

WILSON LINE STEAMER — S. S. BAY BELLE

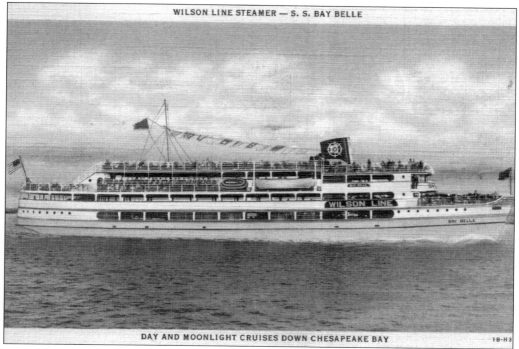

DAY AND MOONLIGHT CRUISES DOWN CHESAPEAKE BAY 1B-H3

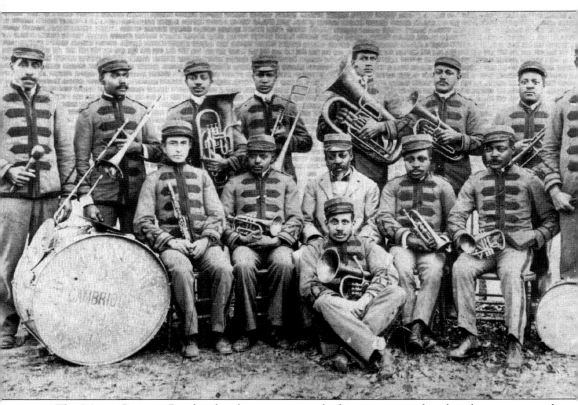

The Merry Concert Band, a local treasure, marched in every parade, played concerts on the Fourth of July and Sunday afternoons at the Spring Valley bandstand, and made impromptu appearances at bonfires when the ice on the Choptank froze thick enough for skating. They traveled from Baltimore and Philadelphia to Cape Charles for engagements and commanded a then-princely 10¢ admission for dances at Samaritan Lodge Hall on Pine Street. William Kiah in 1969 recalled, "It was the time of the famous Philip Sousa, the great composer of band music. We played his stirring composition *The Stars and Stripes Forever* with so much feeling your hair stood on end. We could use more of that attitude these days." Band members included Thomas Moody, Cyrus St. Clair, Harry Colder, Preston Warfield, Sherlock Kiah, William Kiah, Henry Henson, William Boggs, Garrison Humane, Clarence Jones, Henry Croswell, William Jolley, John Mathews, S.E.W. Camper, Dr. Carroll St. Clair, Edward St. Clair Sr., Walter Camper, William Colemen, Howard Jarvis, and Bau Jenifer.

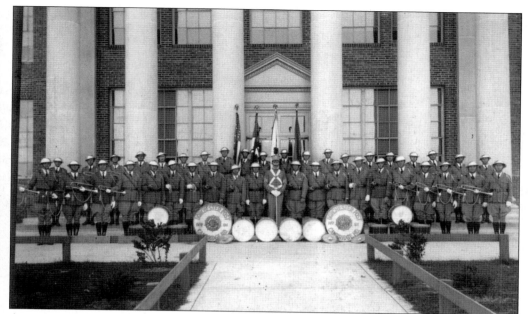

American Legion Post #91 organized a Drum and Bugle Corps after the Great War that marched and performed at celebrations in Cambridge and beyond for many years. Initially appearing on the Second Armistice Day Celebration, they won many prizes, including first-place at the Labor Day Parade in Washington, D.C. Under leader Dorsey V. Burnham, they were state champions of the Maryland Legion Convention in Ocean City.

Spring Valley got its name from a spring that bubbled up between the courthouse and The Hill, a source of drinking water from earliest times. A domed, circular spring house was replaced early in the 1900s with this Victorian-style bandstand. Cambridge boasted several uniformed bands, including the Citizens Band, Merry Band, Legion Drum and Bugle Corps, and a Fire Company Band. John F. Kennedy campaigned at this site in 1960.

Maryland Musings

High Street, Cambridge, and there you are,
A smiling street and an olden way,
Where shadows go by of the dames that dwelt
In the Dorset gardens of yesterday.

And here such a garden upon the right,
Up from the river, still prim and sweet,
Where Doctor Bayly, in auld lang syne,
Made Eden blossom in old High Street.

Back from the house, then the dream begins,
And the old box hedges its squares outline,
Where the homely blooms of the olden days
In the grace of the bloomy dreams still shine.

A tamarisk tree, and the smoke bush, too,
And the hollyhocks and the sunflower wall,
And the nameless Grace of a day that is dead
O'er garden and house and the hedge and all.

The friendly doctor - that must be he
Still bending low in the shadow there
In the loved old garden that knew him well
For his gentle pride and his constant care.

A strawberry bed, and a fig tree, fresh
With its green young fruit and its vigorous leaf;
And the noble trees, and beyond the fence
The ancient tombs of the parish grief.

An Anonymous 19th Century Poet

The above verse was written under the pseudonym "Bentztown Bard" and appeared in the *Baltimore Sun*. It was actually written by Folger McKinsey, whose "Good Morning" column appeared in that paper for 45 years. After his retirement, public demand persuaded the *Sun* to keep his column going an additional year with reruns.

This saucy young lady posed in costume around 1917. Halloween was a big occasion in Cambridge, but only one of many delights of growing up on High Street. Sunday, after the Christ Church congregation dispersed and finished dinner, there would be concerts in the bandstand at Spring Valley. Drummers often arranged their sales trips so they could weekend in Cambridge and enjoy the delicacies of the season. Undoubtedly, some of them drifted over from the Dixon or sat rocking on the double porches listening to the music. (Those inclined to a sip of whiskey had to pack it along, as the citizens of Cambridge had opted to stop public sales of intoxicants.) All week horse-drawn omnibuses rattled up and down the brick street carrying passengers to and from steamboats docked at Long Wharf. Merchants added to the traffic sending orders of dry goods or groceries around by their delivery wagons. A special occasion would be a matinee with mother at the Grand Opera House, slipping out at intermission to Whitey Barth's Candyland for a treat.

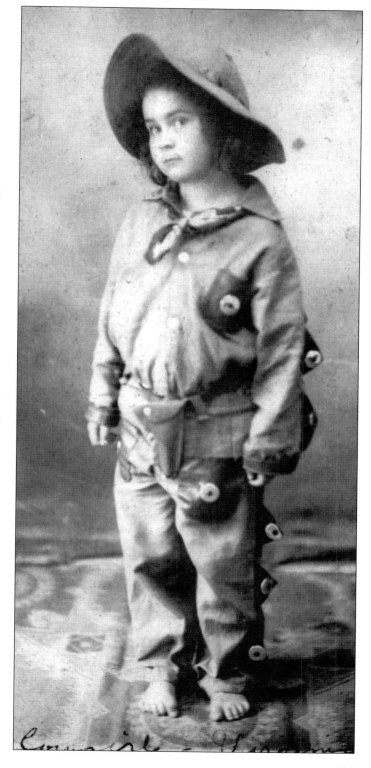

An all-star team, including the Eastern Shore's immortal Jimmy Foxx of Sudlersville, Maryland, exhibited their talents following the 1936 season at the Phillips Employees' Park at Washington Street and Route 50. Posing along with the team are Albanus Phillips and W. Grason Winterbottom. From left to right are the following: (front row) Oscar Roettger and Henry Oana (Baltimore Orioles), Billy Werber (Boston Red Sox) Max Bishop (Philadelphia Athletics) Roger Cramer (Boston Red Sox); (back row) Frank Hayes (Philadelphia Athletics), Dick Porter (Newark Internationals), Phillips, Jimmy Fox (Boxton Red Sox), Winterbottom, and Jimmy Deshong (Washington Senators.)

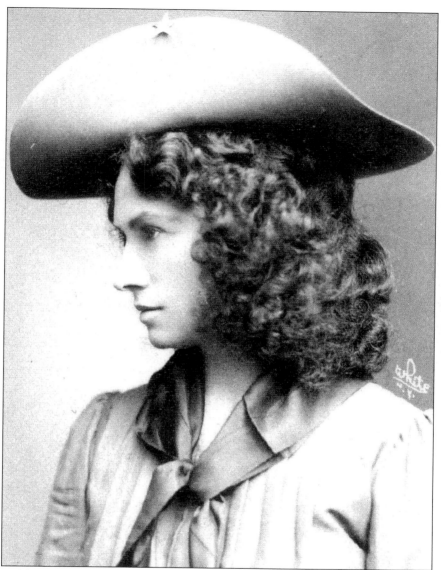

Annie Oakley (1860–1926) gained worldwide fame with her sharp-shooting. A tiny woman barely 5 feet tall and 95 pounds, she learned to shoot game of necessity after the death of her father. She never seemed to aim but simply pointed and shot so accurately spectators could not believe their eyes and suspected trickery. In William Cody's Wild West Show, she grew close to Sitting Bull, who had lost a daughter her age after the Battle of Little Big Horn. He gave Annie the moccasins his daughter had made him for the battle. She offered to raise regiments of women volunteers in the Spanish-American and First World Wars, but the government declined. Cambridge was delighted when she chose to build her home on Hambrooks Boulevard. Between road trips, she attended the Cambridge Fair and treated town folk to shooting exhibitions. She also entertained the first Girl Scouts in Cambridge. While living on Hambrooks Boulevard, she wrote the autobiographical *Powders I Have Used* for the DuPont Powder Company and several magazine articles. Her husband, Frank Butler, survived her by 20 days.

The gentlemen above were prominent in kicking off the Eastern Shore League at Cambridge in 1922. From left to right are as follows: (first row, kneeling) John Noble, unidentified, L.D.T. Noble, Emmett Ewell, Frederick Stevens, Sidney H. Henry, unidentified, Daniel Wright, Frank Robbins, and an unidentified youngster; (second row, standing) Carl Bradley, Robert H. Matthews, Calvin Harrington Sr., Ban Johnson (president of the American Baseball League), Sam W. Linthicum, Hon. Emerson C. Harrington, Judge Josiah Bayley of Salisbury, P. Watson Webb, Harry Rue of Parksley, Virginia, Dr. Brice Goldsborough, and J. Vincent Jamison (president of the Blue Ridge League).

Capt. Paul Jones of the Salvation Army and his son Billy patronize young entrepreneurs in 1958. The Fourth of July has always been a major celebration in Cambridge. The festivities culminate with fireworks financed with funds left to the city for this purpose by Francis I. duPont.

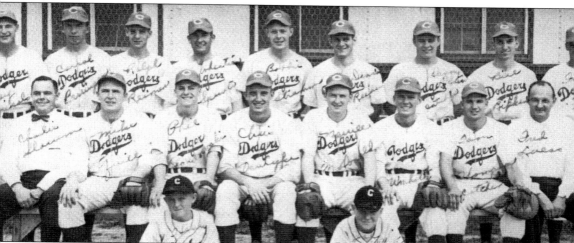

The Eastern Shore League was revived following World War II, largely because Branch Rickey of the then-Brooklyn Dodgers was persuaded by Fred Lucas to build a new ballpark in Cambridge. Lucas had been employed by the Dodgers organization for several years and invited Rickey to Dorchester County on fishing and duck hunting trips to warm him to the area, which was a hotbed of baseball enthusiasm. Rickey committed $60,000 in 1946 to build Dodger Park, which later became J. Edward Walter Memorial Park. Other major league clubs followed suit and the league resumed after a five-year hiatus. Lucas and Rickey's efforts were crowned with success when the Cambridge Dodgers won the 1947 Eastern Shore League pennant with 91 wins and 34 losses, the year's best percentage in professional baseball. Mr. Lucas is pictured with the winning team at the far right of the front row. He also served Dorchester County in the House of Delegates, as county treasurer, and as organizer and president of the Cambridge Little League, Cambridge Colt League, and Cambridge Pony League.

In 1952, Emerson and Sarah Stafford celebrated Valentine's Day at a dance sponsored by the Modernettes at the Elks Lodge on Pine Street. The lodge house was a victim of the 1967 fire. In happier days such acts as Count Basie, Chick Webb's Band with young Ella Fitzgerald, and Patti LaBelle and the Blue Belles, performed here. The white community, which was welcome to enjoy music at the Elks, sat on a separate peripheral level.

It was Halloween when Elsie McNamara came under attack at *The Daily Banner* by two co-worker vampires. Luckily, the victim and longtime columnist and editor survived the ordeal to go on producing "Rocking Chair" columns that Cambridge loved to read.

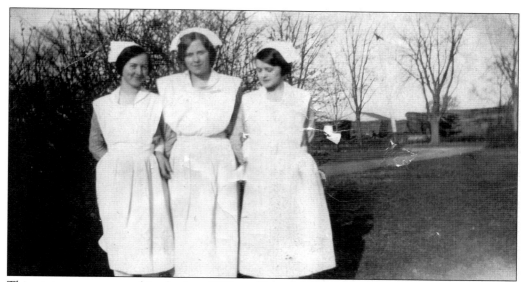

This picture was snapped in the late 1920s as (from left to right) Priscilla VanHuisen, Edwina Haring, and Eleanor Slacum got off duty at sunrise one Easter morning. After a twelve-hour shift, they probably felt too tired to promenade in Easter finery, but were near enough to St. Paul's congregation to enjoy Sunrise Service.

The caption on this 1940 Christmas card says, "Our children caroling 'ere 7 A.M. Come over and carol with us 1941." Nobody would choose to be hospitalized on the holiday, but what a treat it must have been for their patients to have this band of angels come serenading by candlelight on Christmas morning.

The three Cambridge High School students pictured in muskrat fur "playsuits" (from left to right) are Betty Stewart Davidson, Page Hubbard Leonard, and Betty Meekins Harrison. Their picture appeared all over the country when picked up by the wire service in 1938. They were tapped for the frigid February shoot by principal and part-time newspaperman Emmett Andrew. The Associated Press said publicity for the Outdoor Show required "less gore and more glamor" then simply skinning a muskrat. So he had these suits made by Rosalee Hubbard, Page's mother, and gained the show a wealth of attention.

Dorchester County has been home to the Outdoor Show and its contest for National Muskrat Skinning Champion since the days of the Great Depression. A muskrat skinner identified in a 1930s photo simply as the champion appears too relaxed to have actually won the hotly contested title. To date, Wylie Abbott Sr. of Elliott Island has taken 13 titles against all contestants, from Canada to Louisiana.

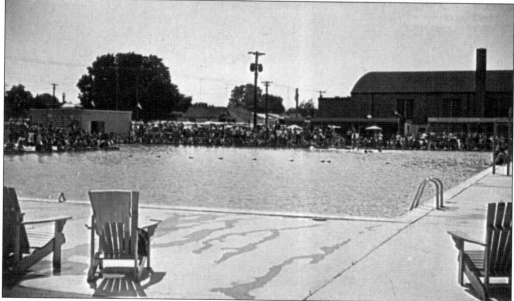

The Rescue Fire Company skating arena and pool were constructed in the 1950s with funds raised by a variety of volunteer projects. When the pool was completed in 1958 at a cost of $150,000, it was the largest swimming pool in the east. The pool is now publicly operated with additions such as a water slide.

Sandy Hill perhaps is an odd subject for a picture postcard, unless the recipient knows its history. This high riverbank was once the site of an Native American village and many artifacts have been discovered there. A large estate named Sandy Hill was renamed Algonquin, the language of the native people. Area children knew Sandy Hill simply as a fine site for sliding.

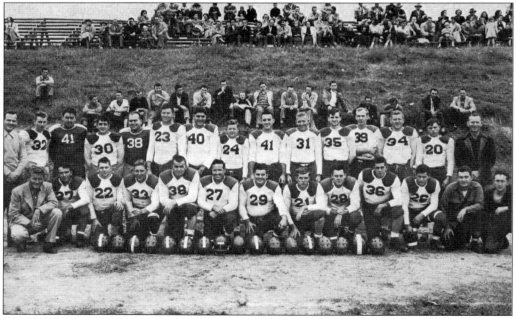

The Cambridge Clippers played semi-pro football for a dozen years in the 1950s and 1960s at Phillips Employees Park on Route 50 at Washington Street. They played teams from Salisbury, Dover, Onancock, and the Chincoteague Naval Base. Coached by postmaster Edward Walter and Robert Davis, they bought their own equipment and uniforms and played for the love of the game.

Judging by the pensive look on the faces of these youngsters, they took this Fourth of July watermelon-eating contest seriously. Making it more interesting was the etiquette used, which only a child could pull off with such style. These kids may not be aware of it, but they were fulfilling a wish of Clement Sulivane and E.P. Vinton in *The Chronicle*, written with Dr. James Bryan, then Superintendent of Schools on July 4, 1884. The distinguished trio's wish was, "May the celebration be repeated year by year, so that our children's children may date back to 1884 the glorious privilege they will continue to enjoy and exercise of welcoming Independence Day with salvos of artillery, ringing of bells, eloquent speeches, brilliant fireworks, martial music, and the shouts of a happy and free people." And may they not worry too much if they swallow a seed in the process.

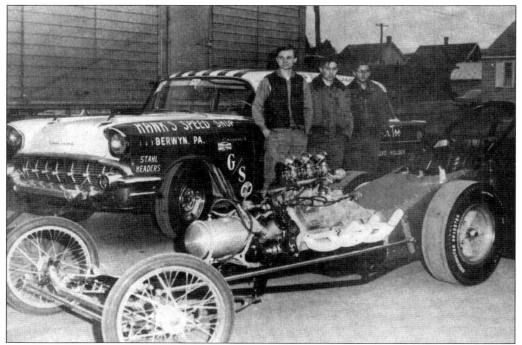

Cambridge has always been fascinated with speed and many trophies have been won by local competitors. Two who stood out in the 1960s were brothers Jay (left) and Buck Wheatley (right), here with Lindy Willey, standing between two of their three racing cars in their speed shop on Maryland Avenue. In front is a *Class D Dragster*. Behind them is the championship stock car, which they had just acquired.

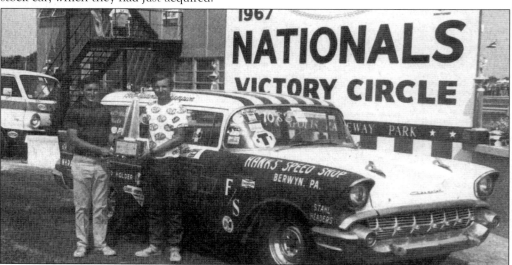

Driver Jay Wheatley (right) stands with his brother Buck in the Victory Circle of the Indianapolis Speedway in Indiana after winning the National Hotrod Racing Association championship. Jay retired from the track at 20 to use his experience as technical advisor and mechanic on a feature film about drag racing, *Two Lane Blacktop* starring James Taylor, Warren Oates, and Dennis Wilson.

Seven

GUARDIANS OF
THE PAST

Meredith House, or LaGrange as it was originally known, is a pre-Revolutionary War house believed to have been built by John Woolford in the 1760s. The site at 902 LaGrange Avenue has been associated with some of Dorchester County's most celebrated families: Phillips, Muse, Ennalls, Wrightson, and Bayly. It is now headquarters of the Dorchester County Historical Society, who preserve its authenticity. The historical society also maintains a research collection in the Maryland Room of the Dorchester County Public Library available to researchers of family or local history.

The Goldsborough Stable, built around 1790, was moved to LaGrange grounds by the historical society. LaGrange was once a portion of the impressive Shoal Creek plantation. The stable is the sole remaining building of Gov. Charles Goldsborough's Shoal Creek. Inside this stable, one can view tools and artifacts from wheelwrights, blacksmiths, and harness makers, as well as a sleigh, wagon, and pony carts typical of an earlier time.

The James B. Richardson Maritime Museum is housed in a former 1889 bank building. It was named for the late "Mr. Jim," a renowned master shipbuilder who was appointed "Admiral of the Chesapeake Bay" in 1979 by Gov. Harry Hughes. The museum is dedicated to those Eastern Shore boat builders who tailor-designed vessels especially for the Bay's watermen who depended on its waters for a living.

The Harriet Tubman Underground Railroad Shop and Museum, located at 424 Race Street, honors the "Moses of Her People" and her dedication to the cause of freedom. The museum displays information on her birthplace and early life in Dorchester County, her association with Frederick Douglass, and local African-American history in general.

Brannock Maritime Museum at 210 Talbot Avenue preserves information reflecting Dorchester County's maritime contributions to regional and national development and defense. Displays chronicle local aspects of conflicts from the Oyster Wars of Chesapeake Bay to global warfare in World War I and World War II.

YE CHOPTANK SCHOONERS

Yonder a sight of the shipping, seen
 through the gate of the street,
The blue of the autumn waters and
 the white sails bellying free;
A glimpse of the fine old harbor, and
 the spars of the oyster fleet,
And the breath of the bay all rosy,
 and the song of the dreaming sea;
Hi rally ye golden seaman,
 And ever ye ships be there,
 To bring me a sight of the shipping,
 And the breath of the Eden air!
Was ever the sun so golden as it
 shines today on you?
 Were ever the docks so jaunty with
 Ships from the seas of joy?
And the waters so fresh, so sparkling,
 so bright with the autumn blue,
And the heart in my bosom beating
 with the blood of a dreaming boy!
Oh, rally, ye Choptank schooners,
 And scurry, ye pungies, here,
From the isles of the streams of
 Talbot
And the wharves of the old Tangier!

 ---Anonymous 1800s poet

Perhaps the Bentztown Bard, poet Folger McKinsey of the *Sun* newspaper, was among the guests of the Oakley Beach Hotel. From its shady porticos he could have watched the panorama of sails passing up and down the Choptank River. A stroll downtown would have taken him down High Street by the boxwood garden of Dr. Alexander H. Bayly celebrated in his poem "Maryland Musings" on page 108.

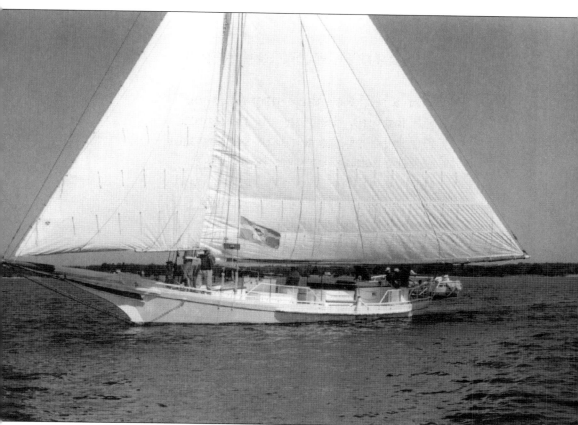

The skipjack *Nathan of Dorchester*, commissioned in 1994, is Dorchester County's goodwill ambassador. Docked at Long Wharf at the end of High Street, this replica of the traditional dredge boats was built as a living museum, serving to educate and protect Dorchester County's maritime heritage and knowledge of the men who worked wintry days harvesting oysters from local waters.

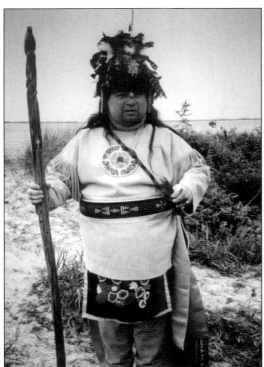

Among events held at the former port terminal at Sailwinds Park is the annual Native American Festival of the Nause Waiwash Band of Indians. On the second weekend after Labor Day, descendants of people native to the area celebrate Native American heritage with music, dance, and craft exhibitions. Pictured is Chief Sewell Winterhawk Fitzhugh on the day he was made chief.

The Trading Post at 403 Aurora Street was built over many years by Lynn Stubbs, in his love to create an atmosphere to house a collection of antique tools, farm equipment, books, and other assortments of history, particularly military memorabilia. The building materials used were salvaged from farm buildings. The wood deck and fence are cut from pickle barrel sides and bottoms of ancient cyprus wood.

Eight
RESORTS OF YESTERDAY AND TOMORROW

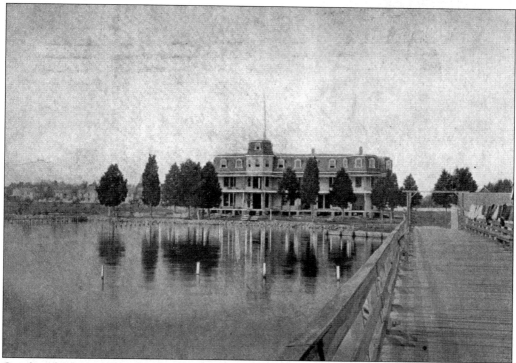

One hundred years ago, Cambridge was excited about the opening of the Oakley Beach Hotel, advertised as a "New First-Class and Homelike Resort." The luxurious resort on the Choptank River at the foot of Oakley Street had 3 stories and 54 rooms. In front of the Oakley Beach Hotel, a 750-foot pier extended into the Choptank and culminated in a pavilion, where bands played for lantern-lit dances. During the day, guests enjoyed fishing or crabbing from the pier or hired boatmen to take them out for a day's sport on the river.

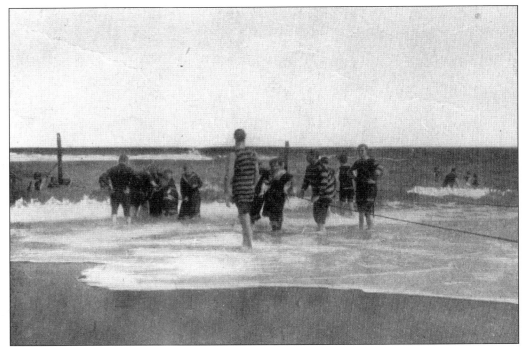

For guests adventurous enough to take a dip in the Choptank, the Oakley Beach Hotel provided every convenience, advertising, "There are 70 commodious bathrooms [changing rooms] on its shore, the bathing suits are kept in the best of condition, the beach has a fine sandy body and every possible provision has been made to add to the pleasure of visitors."

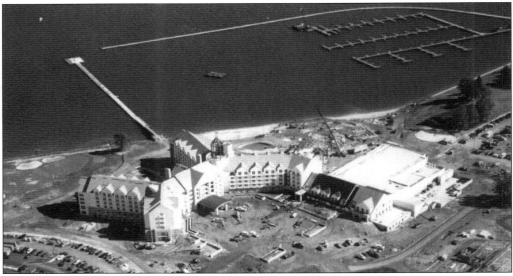

The Hyatt Regency Chesapeake Bay Golf Resort, Spa and Marina now rising on the Choptank River again has Cambridge anticipating a "New First-Class Resort," as was said a century ago of Oakley Beach. Unlike its predecessor, the Hyatt may not offer bathing suit rentals. However, air conditioning, indoor and outdoor swimming pools, a water park, European spa, and a golf course may compensate guests for the omission of rental suits.